S0-AIE-478

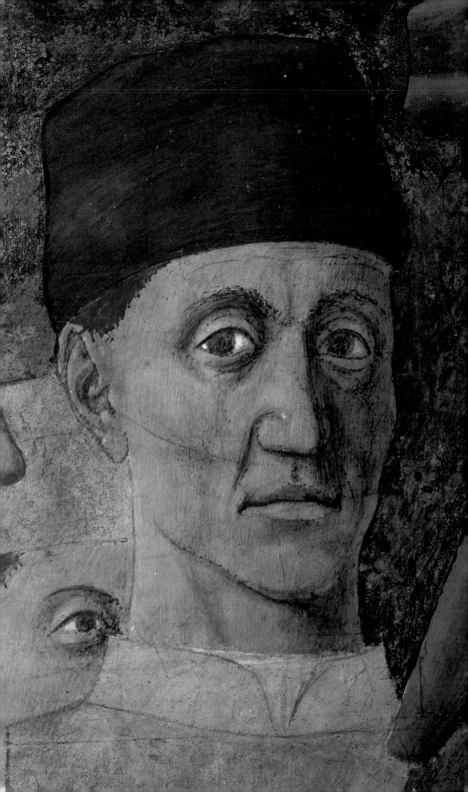

ArtBook

Piero
della Francesca

DORLING KINDERSLEY

London • New York • Sydney • Moscow

www.dk.com

Contents

How to use this book

This series presents both the life and works of each artist within the cultural, social, and political context of their time. To make the books easy to consult, they are divided into three areas which are identifiable by side bands: yellow for the pages devoted to the life and works of the artist, light blue for the historical and cultural background, and pink for the analysis of major works. Each spread focuses on a specific theme, with an introductory text and several annotated illustrations. The index section is also illustrated and gives background information on key figures and the location of the artist's works.

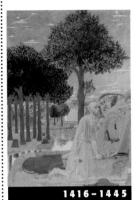

1416–1445

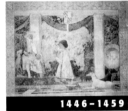

1446–1459

How a merchant's son conquered the Renaissance

Piero's first journeys

■ p. 2: Piero della Francesca, *The Meeting of Solomon and Sheba*, detail, c.1459–64, San Francesco, Arezzo.

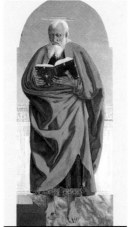

1459–1464

The artistic achievement of Arezzo

1465–1474

Urbino and its environs

1475–1492

The mathematics of art

Index

A bourgeois family

■ *Portrait of Piero della Francesca*, etching from Vasari's *Lives*. Apart from tanning and selling hides, Piero's family grew woad, a plant that yields a blue dye from which the color indigo is made.

Piero della Francesca was born in about 1416 in Borgo Sansepolcro, Italy, into a family of leather and wool merchants. As the eldest child Piero was expected to follow his father and become a merchant, and so a mathematics tutor was assigned to oversee his education. Piero learned the essential tools for commercial accounting: arithmetic, algebra, and geometry, but while he maintained a lively interest in mathematical sciences throughout his life, he soon began to follow his artistic vocation instead. Thanks to his father's connections, Piero managed to join Antonio di Anghiari's renowned studio in Sansepolcro. Thus Piero's artistic apprenticeship took place in a provincial environment and his training was suitably traditional. In 1432 he assisted Antonio in the creation of an altarpiece for the Chiesa di San Francesco in Borgo and, as testified by a document written in 1436, he later worked with his master on the town standards. The talented Piero, however, felt unchallenged by these minor assignments and eventually he left home to indulge his passion for travel.

■ In 1431 the town of Sansepolcro, formerly a domain of the Malatesta family, became part of the papal state, and in 1441 it came under the control of the city of Florence.

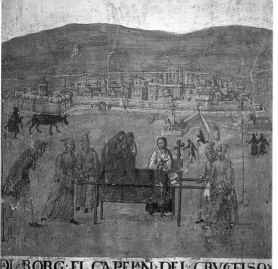

■ Unknown artist, *Votive Tablet of the Fellowship of the Crucifix*, 1523, Museo Civico, Sansepolcro. In the background of this painting is Sansepolcro: enclosed by walls built by the Medici family, the town resembles a fortified four-sided-stronghold. According to legend, Sansepolcro was founded in the tenth century by the Saints Arcano and Eligio, who settled in the valley of the upper Tiber after a pilgrimage to the Holy Land. During their journey they had collected some fragments of the walls of the Holy Sepulchre, after which the new settlement was named.

■ Piero started travelling at a young age and, throughout his life, spent long periods of time as a guest in the most important courts in central and Adriatic Italy. However, he never committed himself to any ruler, and maintained such a close relationship with his hometown that he signed his works "Pietro da Borgo", as if to proudly underline his origins. Many of his works are set in the delicately hilly landscapes of the Tiber valley, and he often painted his hometown of Sansepolcro. Such is the case in this detail of *St Jerome and a Worshipper*, painted in about 1460 (Gallerie dell'Accademia, Venice).

The Tiber valley:
an important crossroads

Its geographical position at the heart of the Apennines has made the Tiber valley an important crossroads for the four regions in central Italy: Romagna, the Marches, Umbria, and Tuscany. In the fifteenth century the region played an important role in both political and artistic developments, and the local art school had always been open to external influences, especially from Romagna. The early 1400s, however, witnessed the beginning of a more intense commercial trade with the Marches and as a result, this region began to play a more inspirational role from an artistic point of view as well. The Camerino School, in particular, could boast a solid artistic tradition that successfully combined long-established practices with the new cultural developments in Florence. The most significant influence, however, came from Siena, where artists were eagerly assimilating ideas developed in Florence in the 1420s. The main artists in this area were Domenico di Bartolo, who worked in the Chiesa del Carmine where Masaccio had created one of his best frescoes, and Sassetta, who in 1437 was invited to create a painting for the high altar of the Franciscan church in Sansepolcro. It was Sassetta's ability to combine traditional fourteenth-century Sienese art with a more modern spatial approach that Piero so admired.

■ Domenico di Bartolo, *Madonna of Humility*, 1433, Pinacoteca Nazionale, Siena.

■ Arcangelo di Cola da Camerino, *Madonna with Child and Saints*, c.1423–25, Galleria Nazionale delle Marche, Urbino.

■ *Sassetta, Madonna of the Snow*, 1432, Galleria degli Uffizi, Florence.

10

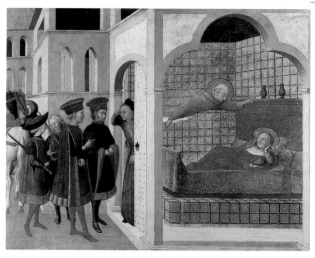

■ Sassetta, *The Beatified Ranieri Rasini Appears to a Cardinal in His Dreams*, 1437–44, Gemäldegalerie, Berlin. This painting, intended for the high altar of the Franciscan church in Sansepolcro, portrays Ranieri Rasini, a friar who was buried in the church. Some episodes of Rasini's life are still portrayed on the altar-step. Influenced by the artist Pietro Lorenzetti, Sassetta created a space of coherent proportions within which he depicted realistic characters.

■ Sassetta, *The Beatified Ranieri Rasini Releases the Prisoners of Florence*, 1437–44, Musée du Louvre, Paris. This is a delicate, touching interpretation of a Franciscan parable. The pure shades used by Sassetta help to bring the scene to life.

■ The upper Tiber valley was the scene of many bitter political disputes and military clashes. In the Battle of Anghiari, in 1440, the people of Florence defeated the Milanese army. This battle was immortalized by Leonardo da Vinci in a work of which only a few sketches remain.

11

BACKGROUND

Humanism: a new vision of the world

At the beginning of the 1400s Florence became the setting for a profound artistic and cultural revolution that was defined, even at the time, as a "rebirth". The origin of this movement was in the rediscovery of the classics by those intellectuals and artists who believed in following the tradition of their classical Greek and Roman counterparts. As such they fostered a new awareness of the influence of the arts in all facets of social life. Innovative artists, encouraged by the classical belief in humankind's ability to understand and dominate nature, experimented with their work. The main protagonists in the creation of a Renaissance style were Filippo Brunelleschi, Donatello, and Masaccio. Brunelleschi began as a sculptor but then turned to architecture and went on to became one of the most famous of all Renaissance architects. His major achievement was the monumental dome of Santa Maria del Fiore. Donatello used classical sculpture as a springboard from which to question stylistic conventions and his characters reveal great expressive power. The youngest of these artists, Masaccio, created a world characterized by humanity and a strong sense of reality.

■ Filippo Brunelleschi, Old Sacristy, San Lorenzo, 1422–28, Florence. The geometrical regularity of the internal space of the sacristy is brought to life by the fluted pilasters and entablature.

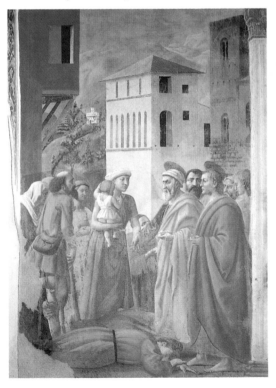

■ Masaccio, *St Peter Distributing the Common Goods*, 1424–28, Chiesa del Carmine, Cappella Brancacci, Florence. The plight of the poor and disabled pervades this fresco, their faces portrayed with dignity while the snow-capped mountains add more drama to their plight.

■ Donatello, *The Feast of Herod*, 1425–27, Battistero, panel from the baptismal font, Siena.

■ Masaccio, *Holy Trinity*, 1426–28, Santa Maria Novella, Florence. In his final masterpiece, Masaccio expressed the potential of perspective by creating a chapel that seems to open up before the viewer. The monumental image of the Trinity and the two other figures are so realistically three-dimensional they seem almost sculpted. The skeleton below is a reminder of the brevity of life.

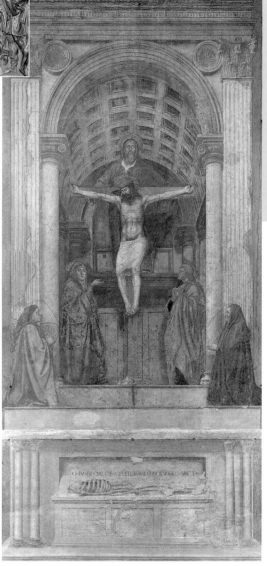

"Bridle and helm of painting"

Mathematical perspective – the the set of rules for representing three-dimensional space on a flat surface – was developed in Florence in the early 15th century. Brunelleschi was the first to demonstrate its principles, which were also applied to majestic effect in the above painting – *Repast for a Childbirth*, Gemäldegalerie, Berlin, 1427–28 – by Masaccio.

BACKGROUND

The Northern Renaissance

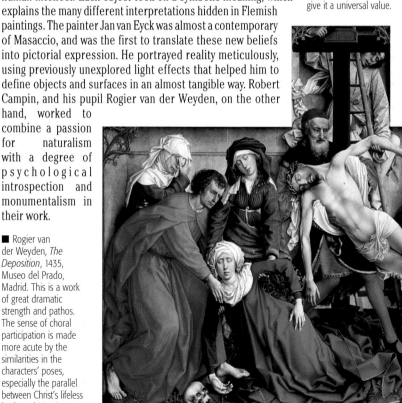

At about the same time that Italy underwent its humanist revolution, a similar process of discovery was taking place in Flanders, in the Low Countries – albeit with different methods and results. While Italian artists developed the use of perspective as a rational principle that could help achieve more realistic representations, Flemish artists focused on a naturalistic portrayal of the world in which each element had equal dignity. Humankind was no longer the sole protagonist of life but merely part of a universe, the magnitude and diversity of which could be comprehended by the human intellect. Each object took on a symbolic meaning, which explains the many different interpretations hidden in Flemish paintings. The painter Jan van Eyck was almost a contemporary of Masaccio, and was the first to translate these new beliefs into pictorial expression. He portrayed reality meticulously, using previously unexplored light effects that helped him to define objects and surfaces in an almost tangible way. Robert Campin, and his pupil Rogier van der Weyden, on the other hand, worked to combine a passion for naturalism with a degree of psychological introspection and monumentalism in their work.

■ Jan van Eyck, *The Arnolfini Marriage*, detail, 1434, National Gallery, London. Flemish art uses mirrors to offer a different view and meaning of the image portrayed, and to give it a universal value.

■ Rogier van der Weyden, *The Deposition*, 1435, Museo del Prado, Madrid. This is a work of great dramatic strength and pathos. The sense of choral participation is made more acute by the similarities in the characters' poses, especially the parallel between Christ's lifeless body and Mary's.

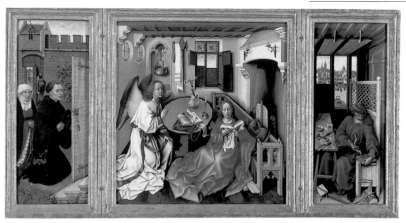

■ Robert Campin, *The Mérode Altarpiece*, c.1425–30, The Metropolitan Museum of Art, New York. Campin, Rogier's master, expressed a calmer view of the world. This central panel is one of the earliest examples of the Annunciation in a domestic interior.

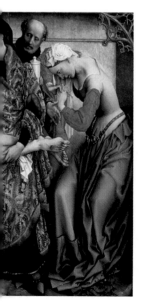

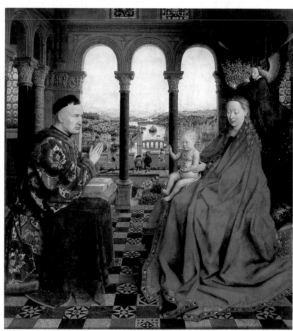

■ Jan van Eyck, *Virgin of the Chancellor Rolin*, c.1435, Musée du Louvre, Paris. Nicolas Rolin was an important politician who used patronage to advance his social stance. He founded the hospital of Beaune and the University of Leuven, and was the patron of van Eyck. This small painting portrays him in a moment of private devotion with the Virgin Mary. The scene takes place in a sumptuous palace that looks onto a delightful landscape.

Florence under Cosimo the Elder

Cosimo de' Medici's ascent to power in 1434 marked the end of a time of internal disputes for Florence and the beginning of a period of political stability and prosperity. Cosimo was from a powerful family of bankers who traditionally were the custodians of the Vatican treasure. With Cosimo at the helm, the Medici Bank expanded beyond the confines of Italy and opened branches in Bruges, Geneva, and Amsterdam. Thanks to his contacts with these cities, Cosimo knew the extent of artistic developments abroad, and decided to import them into Florence. A quiet, religious man, he was committed to many charities, and often gave generous contributions to religious architectural projects such as the reconstruction of the Convent of San Marco. He also commissioned Donatello to paint the Old Sacristy of San Lorenzo. A friend to intellectuals and humanists, and founder of the Platonic Academy, Cosimo was also a conscientious patron and collector of manuscripts that are now kept in the Biblioteca Laurenziana.

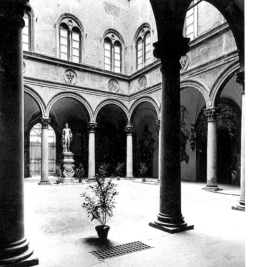

■ Michelozzo, Palazzo Medici Riccardi, c.1440–44, Florence. Cosimo's artistic patronage focused mostly on architecture, which he considered the most noble art. Although he admired Brunelleschi, when Cosimo decided to build the Medici family home, he commissioned the less flamboyant Michelozzo, whom he felt was closer to his own ideals of sobriety.

■ Circle of Piero del Masaccio, *View of Florence*, c.1472, Bibliothèque Nationale de France, Paris. Under the Medici family Florence experienced prosperity and peace. Within this established republican order, Cosimo created such a large patron-and-client network that the succession of his heirs was guaranteed. Among his successors was his grandson, Lorenzo the Magnificent.

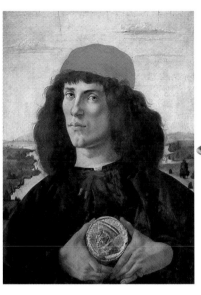

■ Sandro Botticelli, *Young Man with a Medal of Cosimo de' Medici*, 1474, Galleria degli Uffizi, Florence. Botticelli was the artist that best expressed the refined ideals of the court of Lorenzo the Magnificent. The medal commemorates Cosimo, the first person to encourage the civil and artistic values of Florence.

The Council of Florence

Lorenzo Ghiberti, *Solomon and the Queen of Sheba*, c.1425–52, Battistero, Porta del Paradiso, Florence. In 1439 the Council of Florence attempted to reunify the Roman and Greek churches. Emperor John Palaiológos and his followers left such an indelible impression that even Piero portrayed him in his later works, along with characters dressed in oriental clothes.

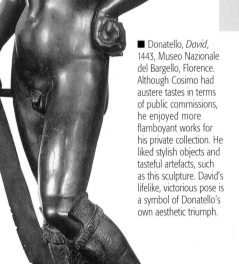

■ Donatello, *David*, 1443, Museo Nazionale del Bargello, Florence. Although Cosimo had austere tastes in terms of public commissions, he enjoyed more flamboyant works for his private collection. He liked stylish objects and tasteful artefacts, such as this sculpture. David's lifelike, victorious pose is a symbol of Donatello's own aesthetic triumph.

Mastering the elements: perspective, light, and hue

When Piero arrived in Florence in 1438–39, the cultural rebirth of the city had already started. Although ten years had passed since Masaccio's death, the full impact of his influence was yet to be felt. New painters were inspired by the Gothic tradition, and placed more emphasis on color and elegant compositions. Thanks to the many collectors among the Florentine bourgeoisie, Flemish paintings were becoming increasingly well-known, and several painters showed interest in their refined use of light. One of the first artists to act on these innovations was the Dominican friar Fra Angelico, who combined the rules of perspective with bright, pure colors in which light acquires a quasi-mystical aura. Filippo Lippi also experimented with light techniques, especially after becoming familiar with northern European art during a stay in Padua. His works use a subtle play of light and shadows to portray delicately real scenes. Paolo Uccello focused on bold perspective solutions, an obsession that led him to an almost metaphysical view of the world. His mathematical rigor and the epic quality of some of his paintings heavily influenced Piero's works.

■ Fra Angelico, *The Circumcision*, c.1450, Museo di San Marco, Florence. This work once decorated a section of a silver cabinet in which votive offerings for the Convent of San Marco were kept.

■ Fra Angelico, *The Coronation of the Virgin*, c.1435, Musée du Louvre, Paris. The sense of spatial depth in this painting is rendered by the marble flooring that leads up to the triumphant steps of the throne. The whole scene is bathed in a bright light that enhances the colors and surfaces, enabling them to come alive.

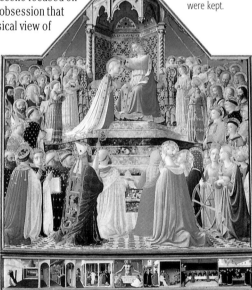

■ Paolo Uccello, *The Flood and Waters Subsiding*, detail, c.1447, Santa Maria Novella, Chiostro Verde, Florence. Initially influenced by the late Gothic tradition, Uccello became fascinated by the expressive possibilities of perspective, and experimented with many daring solutions. In this painting Uccello proves his dexterity with perspective. The fresco portrays the terror of humans in the face of the Flood as they try to save themselves by hanging on to objects floating around. The figures are shortened and made more grotesque by the fear enveloping them. The collar worn by the giant in the foreground recalls the hats typical of that time, the *mazzocchi*.

■ Filippo Lippi, *The Tarquinia Madonna*, 1437, Galleria Nazionale d'Arte Antica, Rome. This tender embrace of the Virgin Mary and Child is bathed in light.

■ Paolo Uccello, *St George and the Dragon*, 1439–40, Musée Jacquemart-André, Paris. The chivalric theme of Saint George killing the dragon and rescuing a princess was very popular in Gothic art. Paolo Uccello gave this theme a personal interpretation. The scene takes place within a fairy-tale landscape made even more unreal by the use of clashing colors. As a result, the events in the painting appear to take place in a timeless dimension.

The influence of Domenico Veneziano

Thanks to Pope Eugene IV's sojourn in Florence, and the presence of different artists such as Pisanello and Alberti, the city had become a cosmopolitan environment by the end of the 1430s. Such varied influences had a great impact on the artistic development of Piero della Francesca, who blossomed amid these humanist surroundings. He was struck by the strict morality of Masaccio and the classical dignity of Donatello's sculptures, but the single most formative experience of this period was his collaboration with Domenico Veneziano. It is likely that the two artists had met in Perugia, where Domenico had stayed in 1438 to create a fresco for the nobleman Braccio Baglioni. Domenico's style was influenced by the magnificent court tradition, which had been especially successful in northern Italy. With his teacher, Gentile da Fabriano, he travelled to Florence and Rome where he absorbed a more modern style. When he moved from Perugia to Florence in 1439, he was commissioned to paint the *Life of the Virgin* in the Chiesa di Sant'Egidio. Although Piero collaborated with Domenico on this work, the work is no longer in existence and, as a consequence, the extent of Piero's contribution will now never really be known. It is safe to assume, however, that he was affected by Domenico's attempts to portray reality in a naturalistic way. Eventually Piero completed Domenico's work, achieving perfection in the synthesis between perspective and the sensitive depiction of light.

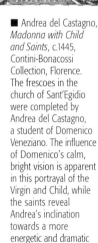

■ Andrea del Castagno, *Madonna with Child and Saints*, c.1445, Contini-Bonacossi Collection, Florence. The frescoes in the church of Sant'Egidio were completed by Andrea del Castagno, a student of Domenico Veneziano. The influence of Domenico's calm, bright vision is apparent in this portrayal of the Virgin and Child, while the saints reveal Andrea's inclination towards a more energetic and dramatic portrayal of humanity.

■ Domenico Veneziano, *Adoration of the Magi*, 1439–41, Gemäldegalerie, Berlin. A noble procession stops in front of a hut during a hunt. The man wearing a black and white suit and holding a falcon is Piero de' Medici, who commissioned this work. The landscape is inspired by Flemish naturalism.

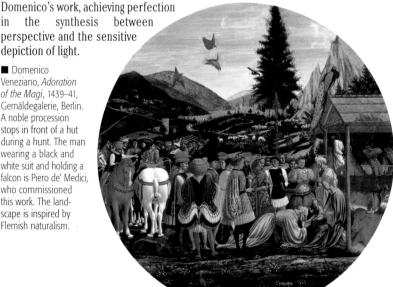

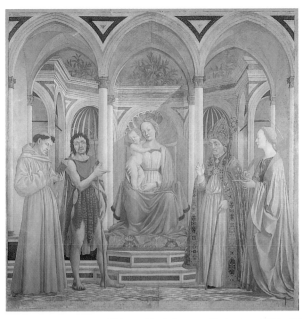

■ Domenico Veneziano, *The Magnoli Altarpiece*, 1445–47, Galleria degli Uffizi, Florence. This *sacra conversazione* takes place within an open gallery decorated with classically elegant marble inlaying. The uniform architectural space is emphasized by the saints surrounding the Virgin on the throne. The most original element of this work, however, is the rendition of light. The scene is bathed in spring light, which penetrates the gallery illuminating the figures and clarifying the delicate pink, green, and pearly white hues that dominate throughout the painting.

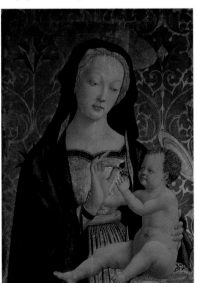

■ Domenico Veneziano, *Madonna and Child*, c.1432–35, Berenson Collection, Settignano. This scene is set in front of a brocade cloth hanging. The warm light shining on Mary's face and clothes creates an atmosphere of tender intimacy within which the gestures between mother and child assume a new meaning.

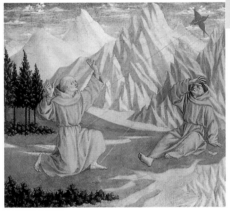

■ Domenico Veneziano, *The Stigmatization of St Francis*, 1445–47, National Gallery of Art, Samuel Kress Collection, Washington. The scenes from the altar-step of the *Magnoli Altarpiece* are scattered between Washington, London, and Berlin. They each describe an important event in the lives of the saints portrayed in the main painting. The dramatic sense of the Franciscan episode is heightened by the setting of the painting, a mountainous landscape in which the barren, rocky terrain is exposed by the cold light of dawn.

Malatesta before St Sigismund, detail, 1451, Tempio Malatestiano, Rimini

At the d'Este court

In 1440 Piero left Florence for good, and from then on he divided his time between Sansepolcro and the main courts on the Adriatic and in Umbria. Piero's choice of a more provincial location reflected his desire to develop his pictorial talents by working on perspective and color purity, as opposed to

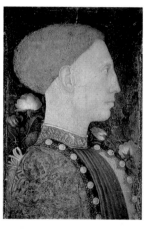

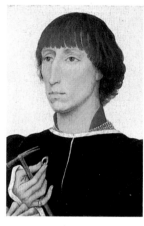

■ Far left: Pisanello, *Portrait of Lionello d'Este*, 1441, Accademia Carrara, Bergamo. A rival portrait to one painted by Jacopo Bellini, this version returns to the profile pose that once featured in many classical medals. Thanks to Pisanello, the Renaissance saw a re-evaluation of this genre.

■ Left: Rogier van der Weyden, *Portrait of Francesco d'Este*, c.1460, The Metropolitan Museum of Art, New York. This portrait of Lionello's illegitimate son was executed in Bruges, where Francesco was at the service of the Duke of Burgundy.

the discipline of drawing, which was the central element of the artistic evolution in contemporary Florence. The new rulers of the smaller courts were eager to give their conquests cultural legitimization and so they were generous patrons. Piero's travels around central Italy indirectly encouraged new art schools that acted locally and independently of Florence. After a time in Pesaro and Ancona, Piero moved to Ferrara in 1446–47. Lionello d'Este, lord of the city, was interested in both humanist studies and in the arts, a combination that he successfully exploited by having the small studio of the Muses in Palazzo Belfiore decorated.

■ The construction of Castello Estense began in 1385. A symbol of the family's powerful influence, it was also the garrison of the army.

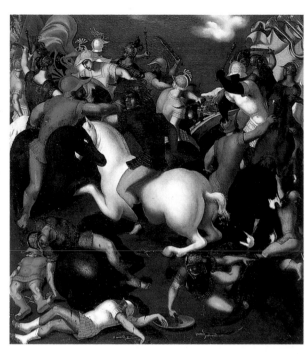

■ Anonymous Ferrarese artist, *Battle Scene* (after a lost fresco by Piero), c.1540, Walters Art Gallery, Baltimore. While in Ferrara Piero painted a cycle of frescoes for the Castello Estense. Regrettably, these works were destroyed during a fire in the early 1500s. There are, however, two Mannerist copies that can give modern art historians an idea of Piero's originals. Although both copies portray battle scenes, this one places a Moor in the foreground. It is possible that Piero had portrayed a clash between a Christian and a pagan army 15 years before the famous battles of Arezzo.

■ Anonymous Ferrarese artist, *Battle Scene*, (after a lost fresco by Piero), c.1540, National Gallery, London. Lionello's rule coincided with a fortunate time of figurative research in Ferrara, a program encouraged by the many humanist interests of the prince himself. Lionello owned several paintings by the Flemish artist Rogier van der Weyden, who travelled to Ferrara in 1449.

Piero's familiarity with Rogier's work had a profound impact on his own style, as proven by the rich brocade clothes and the meticulous research of pure light effects. These touches reveal Piero's careful study of oil and color techniques. The artist even went so far as to work on a new pigment that would help him render the bright yellow hue used by Flemish artists.

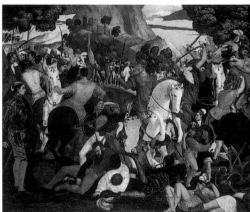

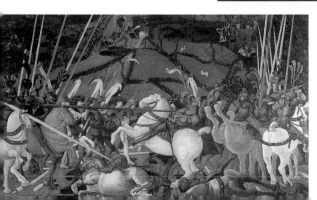

■ Paolo Uccello, *The Battle of San Romano*, c.1456, Galleria degli Uffizi, Florence. In this work Uccello's daring perspective solutions reach a nightmarish effect, particularly in the bodies of the horses lying in the foreground.

BACKGROUND

Sigismondo Pandolfo Malatesta

At the beginning of the fifteenth century, the domain of the Malatesta family extended from Cesena to Senigallia and, until 1434, it also included Sansepolcro. The social and commercial links between eastern Tuscany and the Adriatic regions around the mid-1400s could have been one of the reasons for Piero being called to Rimini in 1451. The chief advisor to Sigismondo Pandolfo Malatesta, Lord of the city, was Jacopo di Alberigo degli Anastagi, who came from one of the most influential families in Borgo Sansepolcro. Sigismondo's first priority was the construction of Castel Sigismondo, a defensive fortress surrounded by strong walls. Its irregular plan and uneven profile were meant to embody the awesome nature of medieval power. At the end of the 1440s Sigismondo, impressed by the Florentine Renaissance, started a conscious programme of artistic renewal in Rimini, and he enrolled the talents of Leon Battista Alberti, Agostino di Duccio, and Piero. The next few years witnessed the creation of many eclectic works, some of which mixed humanist ideals with more traditional Gothic beliefs. A famous example of this combination is the Tempio Malatestiano, which Piero della Francesca decorated with a fresco portraying Sigismondo.

■ Matteo de' Pasti, *Castellum Sismundum*, c.1450, British Museum, London.

■ Arch of Augustus, Rimini. This is the oldest Roman triumphal arch. It was erected in 27BC in honor of the Roman emperor who rebuilt the via Flaminia, a road that joins the via Aemilia in Rimini.

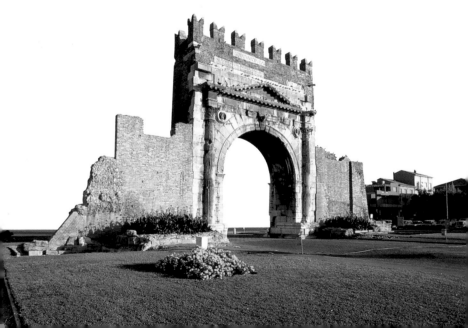

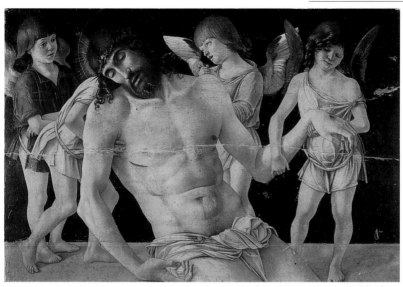

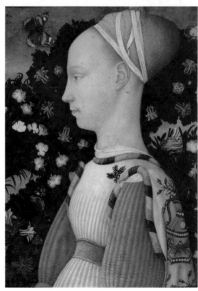

■ Giovanni Bellini, *Pietà*, c.1465–68, Pinacoteca Comunale, Rimini. This work of vibrant pathos, commissioned in the 1460s by Sigismondo, shows Mantegna's influence in the sculptural severity of the figures. However, the painting is made delicate by Bellini's palette of soft tones.

■ Pisanello, *Princess of the d'Este Family*, c.1440, Musée du Louvre, Paris. Although there is no definite answer as to the identity of this woman, it is likely that she is Ginevra d'Este, sister of Lionello, whom Sigismondo Malatesta married in 1434. The existing political link between the two families was consolidated by a careful marital alliance.

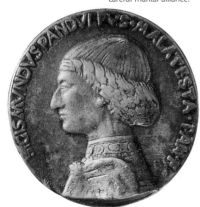

■ Matteo de' Pasti, *Medal Portraying Sigismondo Pandolfo Malatesta*, c.1450, The Metropolitan Museum of Art, New York. This celebratory medal established the official image of this powerful ruler, setting such a widely recognized precedent that even Piero based his portrait of Sigismondo on it. Using a bust or another portrait as a source of inspiration for painters was not unusual.

The Tempio Malatestiano

In 1446 Sigismondo Pandolfo Malatesta commissioned the construction of a family chapel in the Gothic Chiesa di San Francesco. However, when he became convinced of the need to erect a mausoleum for himself and his descendants dedicated to his patron saint, the chapel began to take over the rest of the building, which was inevitably transformed. The Lord of Rimini commissioned Leon Battista Alberti, possibly the greatest architectural theorist of the fifteenth century, to carry out his new plans. Alberti's project was inspired by Roman architecture, and referred to the building as a whole. However, Sigismondo decided to distribute different tasks to different artists and, for the decoration of the interior of the building, he gave a large degree of artistic autonomy to Matteo de' Pasti, the foreman, and Agostino di Duccio, who completed a great number of sculptures. The outside of the temple remained the sole responsibility of Alberti, who designed an exterior marked by rigorous proportions, and whose sides were reminiscent of Roman aqueducts. The show-piece of the building, however, was the front, which was inspired by classical Roman arches.

■ *Construction of the Tempio Malatestiano*, miniature of a manuscript from *Epos Hesperis* by Basinius, c.1460, Bodleian Library, Oxford. Building work lasted about ten years before stopping suddenly due to a political and economic crisis.

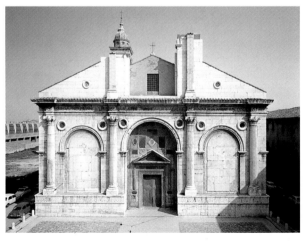

■ Tempio Malatestiano (designed 1447–50), front, Rimini. The front of the building is divided into three parts and is an explicit reminder of the main classical monument in Rimini, the Arch of Augustus. Alberti's design mirrored his love of monumental elements inspired by classical architecture. In turn, this ideal of solemnity agreed with Sigismondo's ambitious dynastic plans.

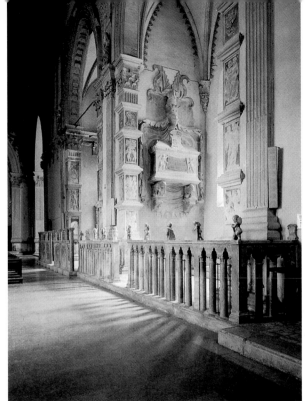

■ Tempio Malatestiano (designed 1447–50), interior, Rimini. Alberti did not personally oversee the temple's construction. The position of foreman was given to Matteo de' Pasti. "That which you do not play, makes music seem discordant", wrote the architect to Matteo, criticizing the latter's divergence from his original plans. The interior of the temple is a celebration of garlands and Gothic cherubs.

■ Agostino di Duccio, *Relief*, c.1449–57, Tempio Malatestiano, Rimini. In his reliefs, the Florentine artist portrays medieval and Christian themes. His style is smooth and decorative, and it reflects the tone of aestheticism in the temple.

■ Agostino di Duccio, *The Moon*, c.1449–57, Tempio Malatestiano, Cappella dei Pianeti, Rimini. Duccio's work caused a sensation, and was criticized by Pope Pius II, who accused Sigismondo of turning a Christian church into a pagan temple. The building's real interest lies in the distinction between its austere exterior and the rich decorations inside. Classical elements are contrasted with the exuberance of the Adriatic courts, as if to reflect the resistance of tradition to the changes brought about by Humanism.

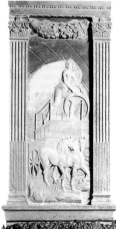

29

Malatesta before St Sigismund

Painted in 1451, this fresco was detached and transferred onto canvas in 1943 due to its poor state of preservation. It is still housed in the place for which it was created, the Chapel of the Relics in the Tempio Malatestiano in Rimini.

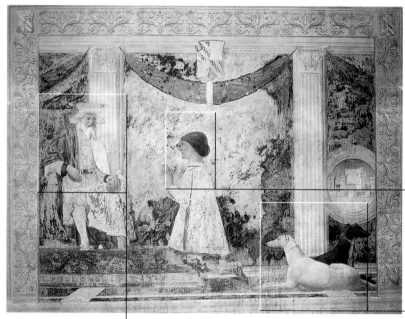

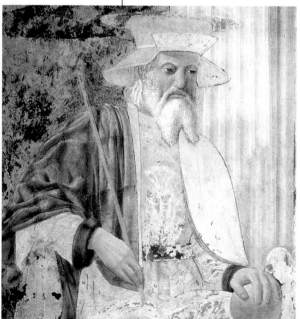

■ Sigismondo Malatesta kneels before his patron saint in an audience chamber. The saint holds a sceptre and a globe, traditional symbols of imperial power. These attributes are not usually associated with saints, and their presence can be explained by the fact that this figure is really Emperor Sigismund, who bestowed upon Malatesta a knighthood in 1433. Although dignified and regal in his pose, the man has a kind face, framed by a white beard.

■ Sigismondo Malatesta, kneeling at the feet of his patron saint, is portrayed in a moment of intense devotion with his hands joined in prayer. Although this painting is ostensibly a devotional picture designed as a votive offering, it is, in fact, a work that ratifies Sigismondo's achievement of political power and dynastic right.

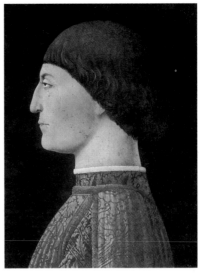

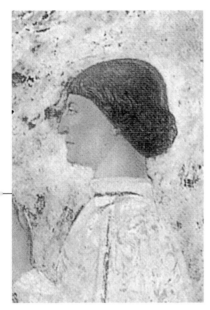

■ Piero della Francesca, *Portrait of Sigismondo Pandolfo Malatesta*, c.1451, Musée du Louvre, Paris. In this portrait Piero carried out a detailed study of the characteristic features of the Lord of Rimini. Sigismondo's sharp profile stands out against the black background. His noble, proud demeanour is heightened by a surly look that reveals his shady, tyrannical personality. The whole effect is made more naturalistic by the subtle highlights in Sigismondo's dark hair.

■ The dogs in the bottom right-hand corner are a delightful touch, and possibly the best part of the fresco. The two greyhounds are looking in opposite directions: the white dog is lying down with his legs stretched out, as if patiently waiting for his owner, while the black one is alert, as suggested by the position of his ears and his stretched neck. The hounds symbolize faithfulness and prudence, two attributes Sigismondo felt he possessed.

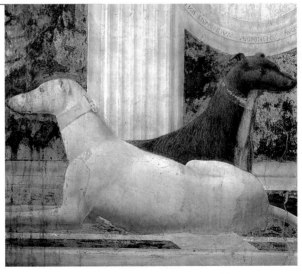

BACKGROUND

Leon Battista Alberti: a universal mind

■ Leon Battista Alberti, *Small Plaque with Self-Portrait*, c.1435, Bibliothèque Nationale, Paris. This plaque was intended as a model for any artist who might wish to portray him.

Leon Battista Alberti was one of the main protagonists of the early Renaissance. If Brunelleschi, Donatello, and Masaccio were the pioneers of the new age, Alberti gave the discoveries and ideals of those years some kind of theoretical order. The son of a Florentine exile, he was born in 1404 in Genoa, a city he hardly ever visited during his lifetime. After studying law in Bologna, he became an apostolic delegate, which enabled him to travel throughout Italy with the papal court. It was during these journeys that Alberti established a network of contacts among the powerful rulers who were later to give him important commissions. It was his transient background that made Alberti's artistic development so similar to Piero's. The two artists met in Florence, Rimini, Rome, and possibly Urbino, and Alberti's beliefs heavily influenced Piero. Indeed, in his most accomplished works Piero seems to translate onto canvas those theories on painting expressed in Alberti's treatise *De pictura* (1435). Leon Battista was a strong believer in Humanism and a scholar of the classics: he embraced many different areas of knowledge, and he is responsible for what are considered the first modern treatises.

■ Leon Battista Alberti, Santa Maria Novella, (designed c.1439–42), Florence. The façade of the church was inserted within the existing Gothic front, which had remained unfinished after the first arcade. Alberti added the classical portal and linked the new elements with a band of inlaid squares and side scrolls: the main harmonizing element, however, is the marble marquetry tiling, typical of the Romanesque tradition in Florence.

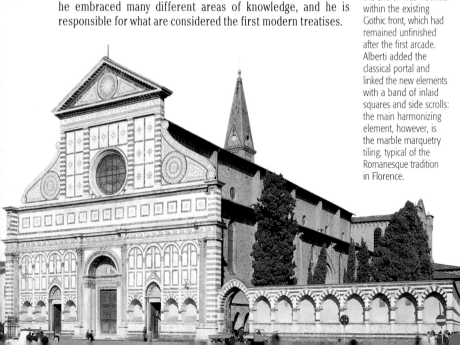

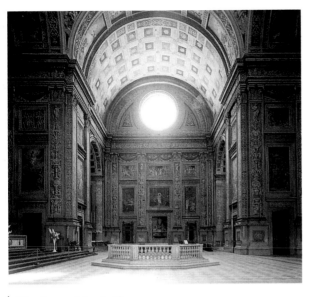

■ Leon Battista Alberti, Basilica di Sant'Andrea (designed c.1470), interior, Mantua. In his final years Alberti worked at the court of Ludovico Gonzaga but he died before his work was completed. This project was finished two years later by the architect Luca Fancelli. The church gives the illusion of being longer than it really is, and its interior is marked by a grand barrel-shaped vault supported on powerful pillars. Situated between columns are chapels that carry some of the same elements of its façade, each with a recess containing a circular window.

"Teacher and inspiration to all things"

Alberti's treatise on painting is the most systematic theoretical work on contemporary figurative arts. He believed that painters must be inspired by nature and represent reality with skillful drawing, tasteful composition, and light. He also asked artists to prove their gratitude to his teachings by inserting his portrait in their works. The example below shows a portrait that Piero included in *The Battle of Constantine* (San Francesco, Arezzo, 1452–66).

■ Title page of *De re aedificatoria*, fifteenth-century manuscript, Biblioteca Estense, Modena. This treatise on architecture (1443–52) is the ultimate summary of Alberti's thoughts on the art of construction.

1446–1459

The Baptism of Christ

This was originally the central panel of a polyptych that was later completed by Matteo di Giovanni. Probably created for the Chiesa di San Giovanni in Sansepolcro in about 1452, the painting is now in the National Gallery, London.

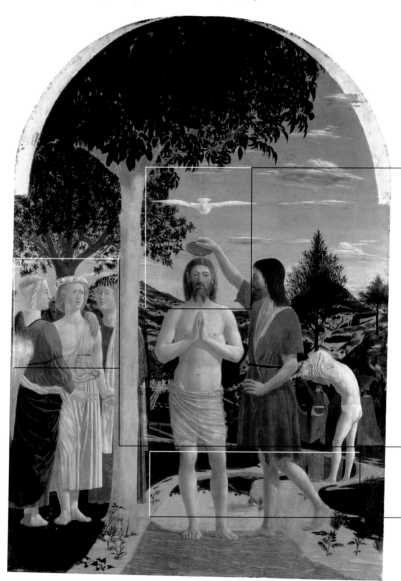

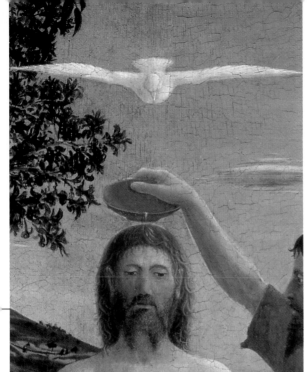

■ The scene, set in a vast sloping landscape, is bathed in the clear light of morning. The compelling, statuesque figure of Christ represents the physical and symbolic centre of the composition. As Christ is about to be baptized, a white dove, the embodiment of the Holy Spirit, descends from Heaven. The glow surrounding the dove highlights the expression of pure concentration on the face of Christ. Piero has created a sacred, untouchable sphere for Christ: even John the Baptist appears to withdraw as he is about to anoint him, as if unable to cross the divide between the earthly and divine.

■ The three angels gathered under the tree seem to express an otherworldly sense of tranquillity as they take part in this divine event. Their close presence, embodied in particular by the gesture of the angel on the right who places his arm on the shoulder of his companion, symbolizes divine harmony.

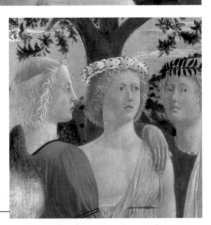

■ Piero's light palette emphasizes the brightness of the colors and Christ's skin has a pearly hue. The most breathtaking element in the painting, however, is the rendition of the waters of the Jordan. The river reflects every detail, from the blue sky and white clouds to the colorful clothes of the people in the background, and adds a dramatic light effect to the whole scene.

BACKGROUND

The fall of Constantinople

In 1453 Sultan Mohammed II extended the expansionistic aims of the Ottoman empire by attacking Constantinople, capital of the eastern Byzantine empire. After a long siege, Emperor Constantine XI was forced to yield on May 29. The church of Santa Sophia, a classical symbol of Christianity, was immediately occupied, turned into a mosque, and renamed Hagia Sophia. The reaction in Europe was swift but ineffectual: the cities of Genoa and Venice, which had important contacts in the Byzantine markets, joined the church in condemning the attack and, on September 30 1453, Pope Nicholas V officially called for a crusade against the invaders. This military intervention, however, never happened, and Mohammed was allowed to extend his domain all the way to Belgrade, from where he also threatened the kingdom of Hungary and the lands around the upper Danube (1456). Following another failed crusade launched by Pope Pius II, the city on the Bosphorus officially became part of the Turkish empire.

■ Ippolito Caffi, *Santa Sophia in Constantinople*, 1843, Museo Correr, Venice. The transformation of the ancient church of Santa Sophia into a mosque was symbolic of the expansion of Islam.

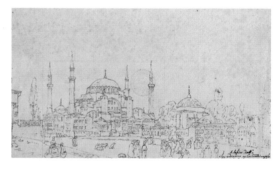

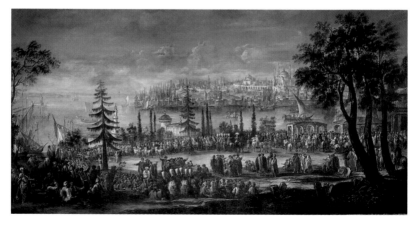

■ *View of Constantinople*, Palazzo Mocenigo, Venice. The city was the gateway to the East.

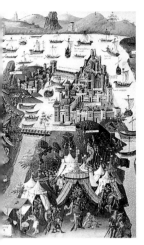

■ The siege of Constantinople, portrayed here in a miniature from the *Voyage d'Outremer* by Bertrandon de la Broquière, lasted over a month. The army of Constantine XI was too small to defend the city against the invaders, and they were forced to yield. Although the sack that followed terrorized the population, it was less destructive than the one carried out by the crusaders in 1204.

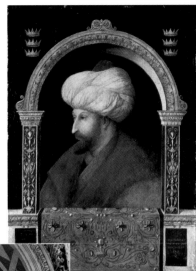

■ Gentile Bellini, *The Sultan Mohammed II*, c.1479, National Gallery, London. In order to emphasize the sultan's prestige, Bellini portrayed him within a marble recess decorated with a cloth decked with precious stones.

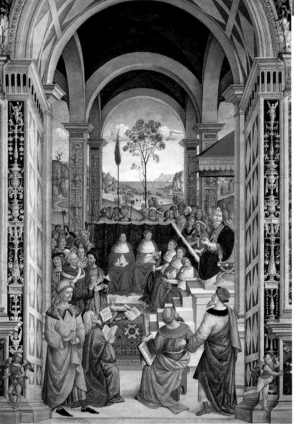

■ Pinturicchio, *Æneas Piccolomini Holding a Congress in Mantua*, 1503–08, Libreria Piccolomini, Siena Cathedral. The 1456 Turkish siege of Belgrade was widely condemned in the West. Æneas Silvio Piccolomini, Pope Pius II, invited the main Christian leaders to the Council of Mantua in 1459: his objective was to organize a crusade against the Turks. Although he declared a holy war against the Ottoman empire, he died in Ancona while waiting for the ships that were to launch the crusade.

Polyptych of the Misericordia

In 1445 the Brotherhood of Mercy in Sansepolcro commissioned Piero to paint an altarpiece for their oratory. Financed by the Pichi family, the work was only completed in 1455. It is housed in the Museo Civico in Sansepolcro.

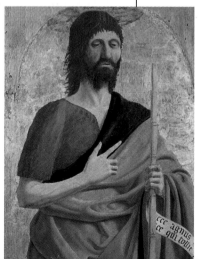

■ This large polyptych took a long time to finish due to Piero's other engagements. Indeed, he did not complete the work himself, but left the small pilasters and the altar-step to his assistants. John the Baptist occupies a privileged place among the saints: he is standing on the right of Mary as the last prophet and precursor of Christ. In spite of the conventional gilded background, Piero manages to give his figure a considerable element of fluid three-dimensionality. His heroic pose is emphasized by the drapery of his red cloak, and contrasted by the meticulous portrayal of his anatomical details. His dramatic presence is reminiscent of Andrea del Castagno's or Donatello's prophets.

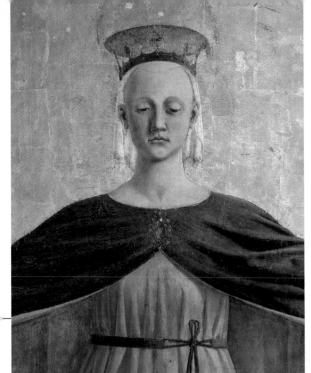

■ The Madonna della Misericordia is traditionally the mother and protector of humans. Following contemporary conventions, Piero portrays her as being much taller than the people she welcomes and protects within her cloak. The dignity of the Virgin Mary is captured within the perfectly geometrical oval of her face, framed by a transparent veil and surrounded by a shortened halo. Her lowered eyes emphasize her suffering as the mother of Christ. Her mysterious monumentality makes her a solid presence in the face of the inevitable sorrows that afflict humankind.

■ The mystical gaze of the Virgin Mary contrasts with the more subtle facial expressions of the imploring men kneeling at her feet. Among this supplicating crowd was likely to be the portrait of somebody from the Pichi family, which financed the work. The young man lifting his face is a self-portrait, while the hooded man wears part of the habit of the Misericordia, worn to carry the dead.

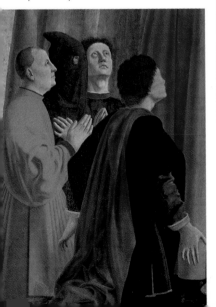

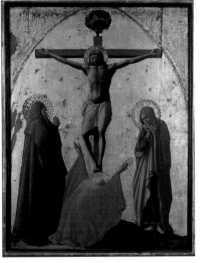

■ Masaccio, *The Crucifixion*, c.1426, Museo di Capodimonte, Naples. The crowning part of Piero's *Polyptych* of the Misericordia is the portrayal of Christ's crucifixion and is an explicit homage to the artist Masaccio.

39

Heroic naturalism:
Andrea del Castagno

For a long time Andrea del Castagno was notorious for allegedly killing Domenico Veneziano in an envious fury, a rumor that was later revealed to be incorrect. His contemporaries nicknamed him "Andrea of the Gallows" after his first public commission in 1440, when he was invited to the Palazzo del Podestà to portray some rebels as they were being hanged. His complex personality flowed into his works, which, influenced by Donatello and Masaccio, featured a detailed study of movement and considerable dramatic tension. It is likely that Piero had the chance to study Andrea's works, especially since both artists had belonged to the workshop of Domenico Veneziano. Maybe it was their common experiences in the master's studio that led to the interest and admiration Piero always felt towards Andrea, a very different artist who shared his ambition to portray humanity in a way that could also express a strong degree of idealism.

■ Andrea del Castagno, *Eve*, 1447, Galleria degli Uffizi, Florence. Andrea's monumental and heroic figures are inserted within fake marble recesses, from which they seem to project out towards the viewer with extraordinary illusionistic effect. A similar solution was later adopted by Piero in his *Magdalen* in Arezzo.

■ Andrea del Castagno, *St John the Baptist*, c.1442, San Zaccaria, Venice. The calmness of the saint is reminiscent of Domenico Veneziano.

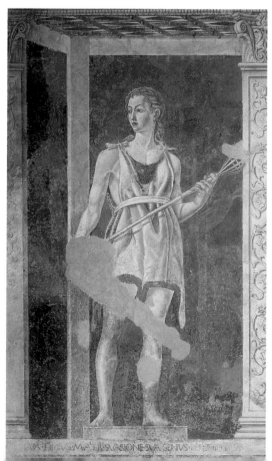

■ Andrea del Castagno, *Holy Trinity and Saints*, 1455, Santissima Annunziata, Florence. The bodies and clothes of the figures, especially Saint Jerome's bare chest, are rendered with great realism. Above them, the Holy Trinity appears at an unusual angle, giving the whole scene a highly dramatic tone.

■ Andrea del Castagno, *The Resurrection*, 1447, Cenacolo di Sant'Apollonia, Florence. Andrea portrays an almost sculpted Christ rising above a sepulchre surrounded by sleeping soldiers. Piero was probably familiar with this work and, around 1465, gave a similar reading of the same biblical episode.

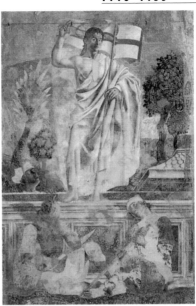

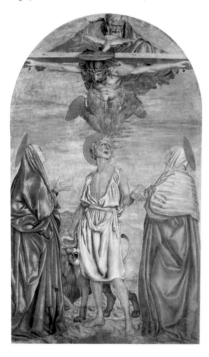

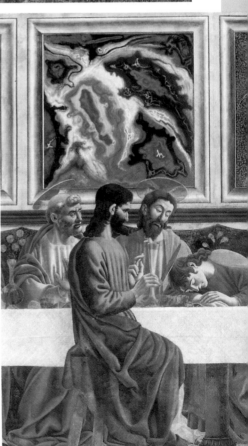

■ Andrea del Castagno, *Last Supper*, detail, 1447, Cenacolo di Sant'Apollonia, Florence. This Last Supper takes place in a sumptuous building decorated with multicolored inlaid marble. Inspired by Alberti's architecture, the perspective of the location is rendered with great dexterity. The most striking element of this work, however, is in the balance of poses and behavior, even in the multiplicity of the apostles' attitudes: John's sweet innocence as he sleeps with his head on the table contrasts with the tense, erect figure of Judas, whose isolated presence conveys an evil omen.

In the Eternal City

■ *Map of Rome*,
from *Geography*
by Ptolemy, Biblioteca
Apostolica Vaticana,
Rome. In the 1400s
Rome enjoyed
an international
cultural climate.

I n about 1459 Piero was invited to Rome by Pope Pius II who wanted him to execute the frescoes for his private rooms in the Vatican. The frescoes, destroyed in a fire soon after their completion, were likely to have constituted a cycle of *Illustrious Men*, whose lives were somehow connected to Pius II, the humanist Æneas Silvio Piccolomini. During his sojourn in the Eternal City, Piero had the opportunity to witness and study classical architecture and sculpture, and was profoundly affected by them. Indeed, they seem to fit perfectly within the artist's monumental and timeless vision of the world and its history. His development in Rome might have been aided or directed by Alberti, who was also there during that time carrying out ordonnance surveys of the Aurelian walls. The first works to reveal the full impact of Piero's Roman experience are his frescoes in Arezzo.

■ Pinturicchio, *Æneas Silvio Piccolomini Elected Pope under the Name of Pius II*, 1503–08, Piccolomini Library, Siena Cathedral. Pius II continued Nicholas V's programme of public works in the city as well as the re-structuring of the papal palaces. His goal was to exalt Rome as a symbol of Christianity.

■ Piero della Francesca or his assistants, *St Luke the Evangelist*, c.1459, Santa Maria Maggiore, ex Cappella di San Michele e San Pietro in Vincoli, Rome. Some art historians claim to recognize the hand of Piero in this badly damaged fresco. It is likely, however, that Piero had delegated the execution of this painting to one of his students, possibly Giovanni da Piamonte.

■ Raphael, *The Fire in the Borgo*, detail, 1514, Stanza dell'Incendio di Borgo, Musei Vaticani, Rome. One interesting theory suggests that Raphael might have painted this fresco on the partition of those rooms painted by Piero that had been destroyed as early as 1459 in a fire.

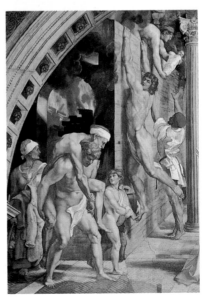

■ *Portrait of Cardinal Bessarione*, from *De Viribus Illustribus* by P. Giovio. Piero's Vatican frescoes focused on illustrious men and carried strong political value. Among the characters portrayed was Bessarione, a cardinal who supported Pius II's crusade against the Turks.

The genesis of a masterpiece

The chronology of Piero's most famous artistic achievement, the decoration of the main chapel of the Chiesa di San Francesco in Arezzo, is still being debated. The work was financed by the Bacci family, who were the patrons of the chapel. The execution of the frescoes had been given to Bicci di Lorenzo in 1447 but when he died in 1452, the commissioners had

to find a substitute. After long negotiations, the family decided to assign the frescoes to Piero. The deciding factor was not just due to his fame, but also to the intervention of Giovanni Bacci, who had important contacts at the papal court and was a friend to many humanists such as Traversari and Leon Battista Alberti. He admired Piero's artistic ability, and had every confidence that he would meet his brief: a complex iconographic programme handling the Legend of the True Cross.

■ Front view of the Chiesa di San Francesco, Arezzo. Started in the second half of the thirteenth century, the church was completed between 1317 and 1377.

■ Left: Arezzo was handed over to Florence in 1384. After that, the city began to lose its cultural and artistic autonomy. The main architectural Renaissance work was carried out by Bernardo Rossellino and Benedetto and Giuliano da Maiano.

■ Interior of the Chiesa di San Francesco, Arezzo. The main chapel is located at the far end of the only aisle, and contains a large painted cross by the Master of St Francis dating back to about 1260. Although it is possible that Piero started his frescoes not long after 1450, after completing the *Polyptych of the Misericordia*, the largest number of paintings was carried out upon the artist's return from Rome in 1459, and completed in about 1464.

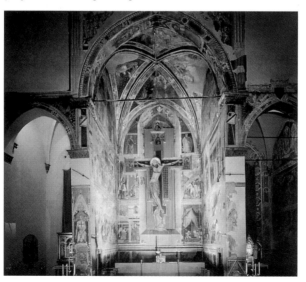

■ Bicci di Lorenzo, *Evangelists*, c.1447–48, vault of the main chapel, Chiesa di San Francesco, Arezzo. The vault of the choir still maintains the frescoes created by Bicci di Lorenzo, the late Gothic artist that preceded Piero in the decoration of the chapel. The four vaulting cells are decorated with the Evangelists and their symbols, rendered with a lively chromaticism that suggests an archaic flavor. In the lower part of the vault within two Gothic recesses Bicci also inserted two doctors of the church. Bicci was forced to leave his work incomplete due to an illness that eventually killed him in 1452, when he was 80 years old.

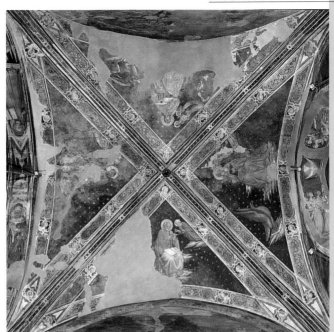

In the name of tradition

Francesco Bacci commissioned the frescoes for the main chapel of the Chiesa di San Francesco from Bicci di Lorenzo in 1447 in accordance with the instructions his father had left in his will. The Florentine artist was renowned for his courtly style and his willingness to take on board the perspective developments of the time. His name is also associated with two fundamental moments in Piero's career: in 1439 Bicci was a gilder in the Chiesa di Sant'Egidio in Florence, where Piero and Domenico Veneziano were also working; and in 1452 his death gave the artist from Sansepolcro his first major breakthrough. This picture by Bicci di Lorenzo shows a *Doctor of the Church*, a detail from the lower right arch of the main chapel.

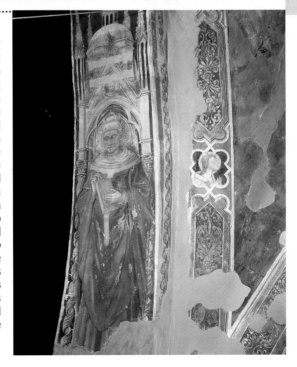

BACKGROUND

The Legend of the True Cross

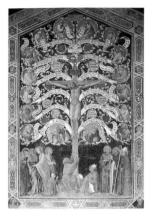

■ Taddeo Gaddi, *The Tree of the Cross*, 1333, Refectory, Santa Croce, Florence. Following medieval tradition, this painting portrayed the *Lignum Vitae*, that is the cross as the heart of spiritual life.

The Legend of the True Cross was given a new elaboration in the 13th century by Jacobus da Voragine in *The Golden Legend*. The main theme is the triumph of the Cross which, from the death of Adam onward, has been guiding humankind to salvation. The legend takes place across the centuries, and the main stages include the death of Adam, from whose mouth the tree of the Cross is born; Constantine's dream, during which an angel predicts the emperor's victory over Maxentius; the miraculous finding of the Cross, and Heraclius' triumphant entry into Jerusalem. However, Piero's interpretation of the legend differs slightly from tradition in his decision to insert the episode of the meeting between King Solomon and the Queen of Sheba, and in the greater relevance given to the two battles that marked the triumph of Christianity over pagans. No doubt his choice was influenced by the need to give legendary events a contemporary feel: the political and religious events in the frescoes were still valid in the mid-15th century at a time when the church was considering a crusade against the Turks to confirm its strength and unity.

■ Agnolo Gaddi, *Beheading of Chosroes. Heraclius Returning the Cross to Jerusalem*, c.1388–93, Santa Croce, Florence.

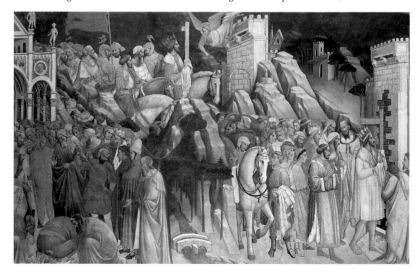

■ Giulio Romano, *The Battle of the Milvian Bridge*, 1524, Sala di Costantino, Musei Vaticani, Rome. Raphael's favorite student made the most of the dramatic potential of a battle. The tangled mass of shortened bodies and the bright colors create a spectacular composition that anticipates the main elements of Mannerism.

■ Agnolo Gaddi, *Invention and Recognition of the True Cross*, c.1388–93, Cappella Maggiore, Santa Croce, Florence. Gaddi's cycle of frescoes was the first dedicated to the Legend of the True Cross. In line with the Giottesque tradition to which he belonged, he focused on narrative events, which he invested with a feeling of intense spirituality.

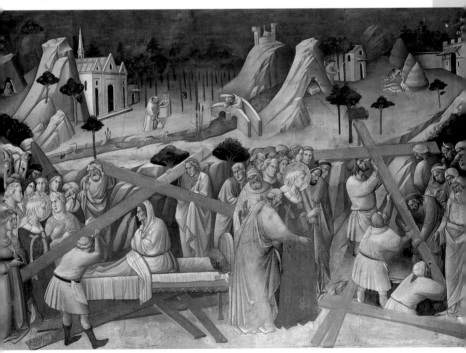

1459–1464

The Death of Adam

This fresco is located within the upper arch of the right wall in the main chapel. It portrays three moments connected to Adam's death and the subsequent birth of the luxuriant tree from which the Cross of Christ was built.

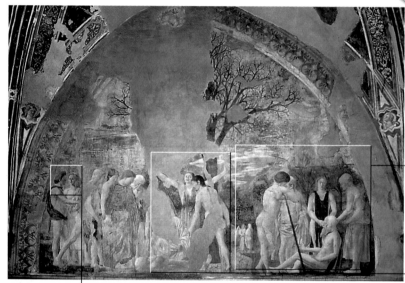

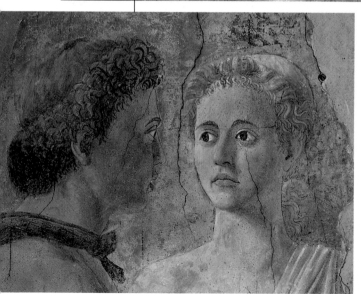

■ Aware of the nearness of death, Adam begs his son Seth to ask archangel Michael for the oil of mercy. Michael, however, denies this favor and gives Adam the seeds of the tree of sin. Upon his father's death, Seth places the seeds in Adam's mouth, from which the tree of the True Cross, symbol of the salvation of mankind, comes to life. Every detail in this imposing rural image underlines the universal meaning of the events, such as the two youths (left) – who signify hope in future generations.

■ Adam appears fatally ill: his weak, ailing body is supported up by an ageing Eve. Piero portrays signs of her physical decay, such as her drooping breasts, with brutal realism. The muted suffering of this moment is revealed in the sculpted pose of the man who has his back towards the viewers: the soft suppleness of his naked body and his head gently leaning against his right arm accentuates the sorrow felt by the whole family at the death of Adam.

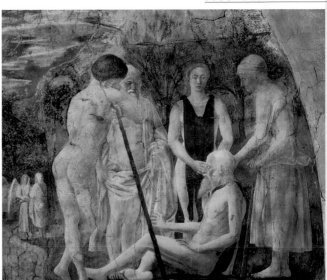

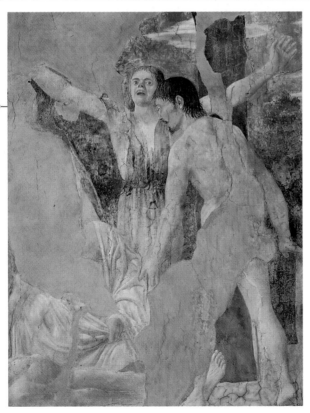

■ Adam's descendants gather around his corpse, forming a funeral procession. The sorrow of the relatives climaxes in the inconsolable desperation of the woman lifting her arms to the heavens with a heartbreaking scream. Adam's death, however, also brings about hope for the new destiny of humankind. Seth plants seeds in his father's mouth and from it the large tree of the True Cross is born. Placed at the heart of the pictorial narrative, the tree dominates the composition. Its story is symbolic of the difficult path of faith, a faith that will triumph thanks to the sacrifice of Christ. Recent restoration has revealed the leaves of the tree, painted in a naturalistic way by Piero.

The Discovery of the Sacred Wood and the Meeting of Solomon and Sheba

This panel is directly beneath *The Death of Adam*, on the right wall. The event portrayed is imbued with a sense of courtly nobility.

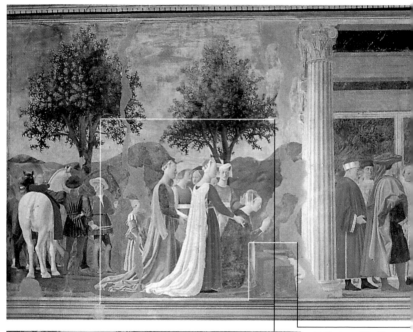

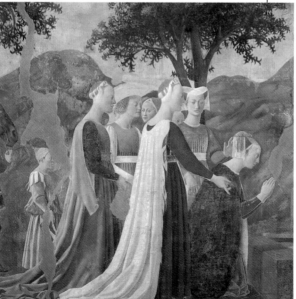

■ The tree of the True Cross has been felled and used as a bridge. As she is about to use it, the Queen of Sheba has a vision: one day that very wood will be used to build the cross upon which Christ will die. She stops to worship it, and later tells Solomon about her vision. Knowing that this indicates the end of the kingdom of Israel, he has the wood buried. The delicate profile and gestures of the queen add to the austere elegance of the scene.

■ The meeting takes place under the wide classical colonnade in Solomon's palace. The sumptuous architecture allows Piero to utilize his interest in perspective to the full.

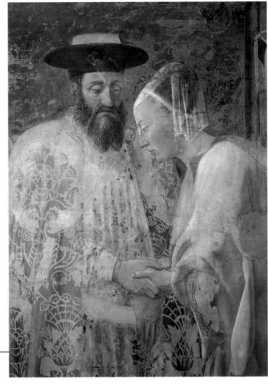

■ The sacred wood is positioned between the two main scenes which are represented as apparently normal episodes of courtly life and rendered with saturated colors. The division, however, is not just a narrative tool, but also an allegorical interpretation of the reconciliation of eastern and western churches. The allegory is given a contemporary feel by Piero's decision to portray King Solomon as Cardinal Bessarione, a strenuous supporter of the crusade against the Turks. This element also instills a propagandistic tone into the whole scene.

53

The Dream of Constantine

This famous episode is on the lower right-hand side of the Crucifix, next to the chapel window. The scene signifies the movement from the Old to the New Testament, and is set during the reign of Constantine the Great.

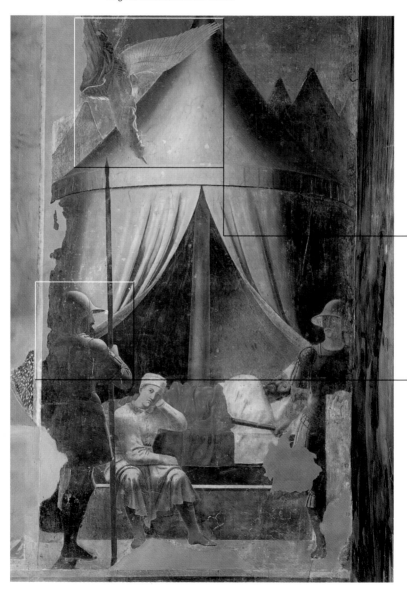

■ On the eve of the battle against Maxentius' army, Constantine worries about the enemy's superiority. An angel appears to him in his sleep and informs him that he shall win the battle as long as he fights in the name of the Cross. The calm of the emperor's nocturnal rest is interrupted by the apparition of the angel, which is rendered with great virtuosity. The angel carries a small cross in his right hand: this, however, is not visible to the viewer, but solely to Constantine, the only protagonist of this supernatural event. The scene is one of Piero's greatest masterpieces.

■ The formal composition of the scene, dominated by the perfectly cylindrical tent, is toned down by Piero's sense of naturalism. The intense light that emanates from the heavenly messenger illuminates deep into the recesses of Constantine's darkened tent. The brightness of the angel does not seem to bother the guards around the sleeping emperor, confirming the intimate nature of the vision.

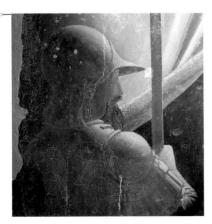

■ Raphael, *The Liberation of St Peter*, detail, 1513–14, Stanza di Eliodoro, Musei Vaticani, Rome. *The Dream of Constantine* was the first image of a night scene. It influenced Raphael, the most talented artist of the next generation, who subsequently created a glittering sky with intense light effects. The night sky heightens the dramatic tension and the symbolic value of this episode.

The Battle of Constantine

This battle scene is placed in the lower section of the right wall of the chapel. It continues the story after *The Dream of Constantine*. Constantine's victory against Maxentius at the Milvian Bridge is rendered with epic tones.

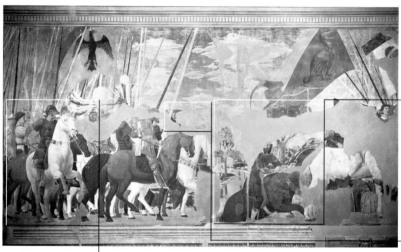

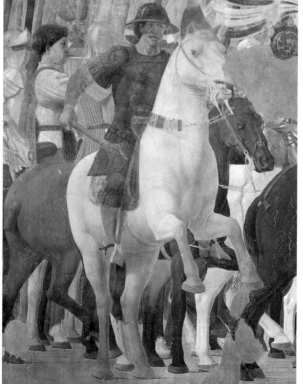

■ Encouraged by the vision of the night before, Constantine seizes a cross and throws himself into the thick of the battle against Maxentius. The enemies are defeated and, as they retreat, they fall into the river from the Milvian Bridge. Ironically, Maxentius himself had given instructions to damage this bridge. The battle portrayed by Piero is not at all bloody: the imperial army is involved in a triumphant procession in the name of the Cross, and their slow, solemn gait is broken only by this warrior coming directly at the viewer. He holds a sword and seems to let out a battle cry, the only real hint at the brutality of the event.

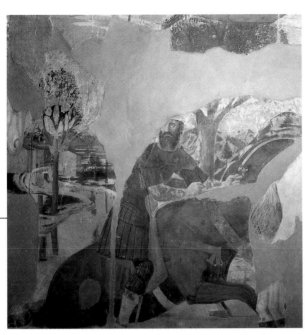

■ Sadly, this part of the fresco is severely damaged. It portrays Maxentius' defeated army as they desperately try to save their lives by climbing up the steep banks of the river. There is no real dramatic tension in the rendition of this retreat: the whole scene seems suspended in a timeless void, and the reality of the battle is only hinted at in the large banners billowing in the wind and obscuring the spring sky. The pagan symbols of a green dragon and a moor must succumb to the unstoppable advance of the imperial eagle.

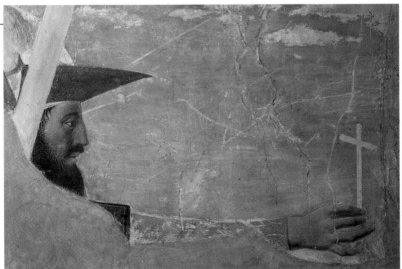

■ The meaning of this scene is embodied by the figure of Constantine, who proceeds at the front of the procession holding a small white cross. His victory is achieved without any bloodshed, a fact that highlights the power of the Christian symbol. Constantine is given the features of the Byzantine emperor John Palaiológos VIII. This detail gives the work a contemporary political message: just as Constantine beat the barbarians by seizing the cross, so shall a modern emperor defeat the infidels by leading the Christian army.

The Finding and Proving of the Cross

This scene occupies the middle section of the left wall, and is directly opposite *The Adoration of the Sacred Wood*, with which it shares a courtly, ceremonial tone. The protagonist of this episode is Helena, Constantine's mother.

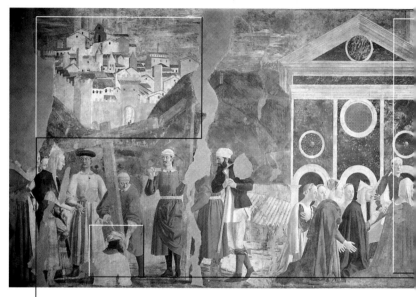

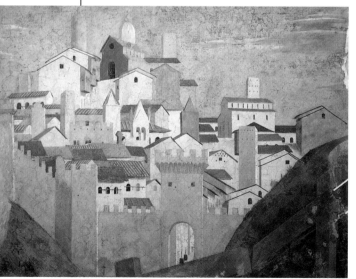

■ Helena decides to look for the True Cross, which has been buried. A Jewish man named Judas leads the royal procession to the right place but, as the Cross is being dug up, the earth also yields those thieves who were crucified with Christ. As Helena waits for a sign, a miracle takes place and the Cross resuscitates a young man. In this section of the fresco, shown here after its restoration, Piero has turned Jerusalem into a medieval city. This delicately poetic episode is made more lively by the clear colors.

■ The test of the Cross takes place within the impressively-rendered perspective of a small city. The street on the right-hand side is a faithful rendition of one in Sansepolcro, and the modern buildings are placed in opposition to the classically sumptuous palace in the background. The axis of the scene is the Cross itself, which projects outward. The position of the figures around the Cross highlights the miracle: the holy wood has resuscitated a young man, who opens his arms in an expression of utter surprise. His naked body is sculpted by light, creating a naturalistic effect that extends onto the shadows on the floor.

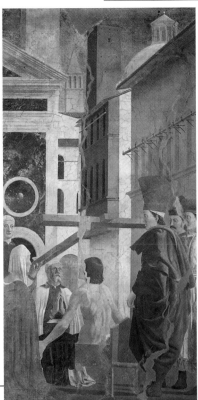

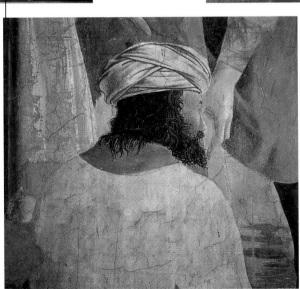

■ Judas, by now converted to the Christian faith, leads Helena's procession to Mount Golgotha, the location of the Cross. This section is animated by vivid realism: the difficulty of the enterprise is revealed by the image of the man waist deep in a hole in the ground. Around him, everybody waits with bated breath: Helena turns a questioning look to Judas, while two men dig up the first two crosses under the curious gaze of a man leaning against a spade.

1459-1464

The Battle of Heraclius

This second battle scene is located in the lower section of the left wall, opposite *The Battle of Constantine*. The narration leaps forward three centuries and continues at the time of the expansion of Chosroes' Persian kingdom.

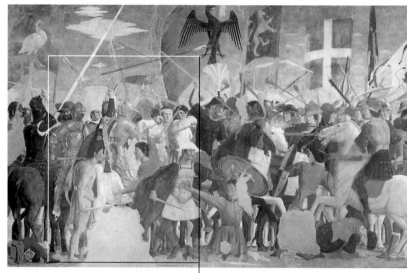

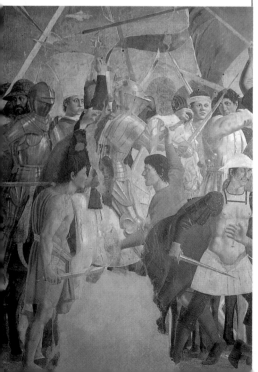

■ In AD615 king Chosroes of Persia stole the Cross from Jerusalem in order to use it as an ornament for his throne. Emperor Heraclius declared war against him and defeated him in a memorable battle, at the end of which Chosroes was beheaded. Although the men in this tight entanglement of human bodies are engaged in extremely gruesome acts, their expressions do not show any rage or fury. The man in the unusual hat playing the trumpet amid the chaos of the battle (shown in the picture on the right-hand side) adds to the confusion of the scene.

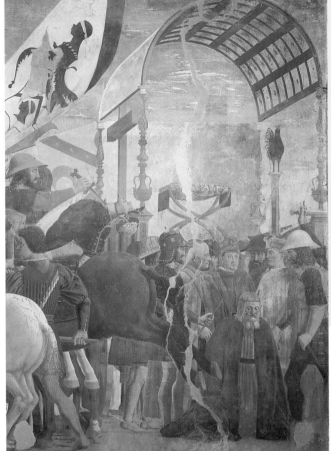

■ Piero focuses on details that reveal the true extent of the human drama in the thick of this bloody battle. The sense of defeat expressed by the man kneeling on the ground is heightened by the blood dripping from his battered body onto the earth.

■ The excitement of the battle makes way for the epilogue of the event. The lushness of the setting reflects Chosroes' pagan taste and underlines his heresy: the canopy is suspended over pilasters shaped like candelabra, and is surmounted by a vault decorated with golden stars. To the right of the kneeling Chosroes is Heraclius: he carries a red helm and a golden sceptre, symbols of victory.

The Exaltation of the Cross

The scene in the arch of the left wall concludes the parable of the Holy Wood, which began with a seed planted in Adam's mouth. This section focuses on Heraclius triumphantly returning the Cross to Jerusalem.

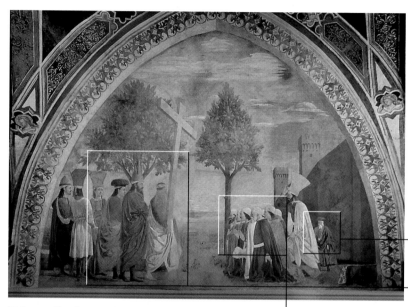

■ Emperor Heraclius takes the Cross back to Jerusalem, but the city proves inaccessible to him and his court. An angel reminds him that Christ entered Jerusalem in a humble way, prompting Heraclius to shed his imperial clothes and enter the Holy City barefoot. The citizens kneel before this unusual spectacle: their delicate features reveal not just devotion, but also amazement at the sight of the emperor in poor, simple clothes. The images on this page show the fresco after a long restoration process.

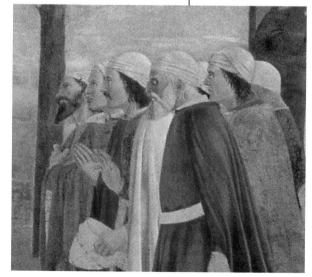

■ Although this arch clearly reveals the intervention of Piero's assistants, the master's own hand is recognizable in the masculine beauty of this figure. The ageing man who walks behind a group of worshippers away from the walls of Jerusalem anticipates similar creations by Piero. The artist's ability to express a concept with a simple, concise element is evident here: in spite of being heavily built, the old man appears overwhelmed by the massive outline of the fortified city. His predicament can be read as a metaphor for the closing of the city doors in the face of the emperor's pride.

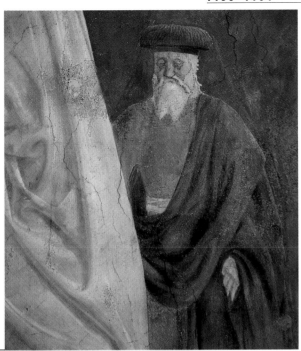

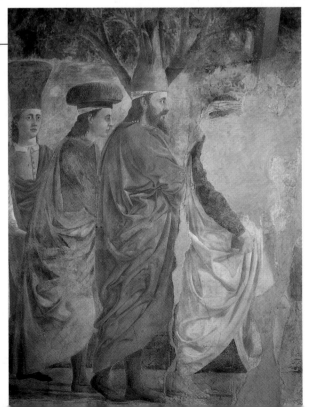

■ The climax of this episode is the exaltation of the Cross of Christ. The simplicity of the fresco enables the viewer to focus on the emotional centre of the work, that is Heraclius carrying the Cross into Jerusalem. It seems that, for this episode, Piero respected the legend in every detail: Heraclius wears a simple blue garment and a pink cloak. Following Christ's example of humility, he is also barefoot as he leads his procession into the city. The meaningful, dignified poses of the characters are emphasized by the heavy folds of the drapery, and the slow gestures express Piero's ideal of noble humanity.

The Annunciation

One of the best preserved frescoes in the church, this episode occupies the lower left section next to the window. The event is not related to the story of the Cross, but was maybe chosen by Piero for its universal meaning.

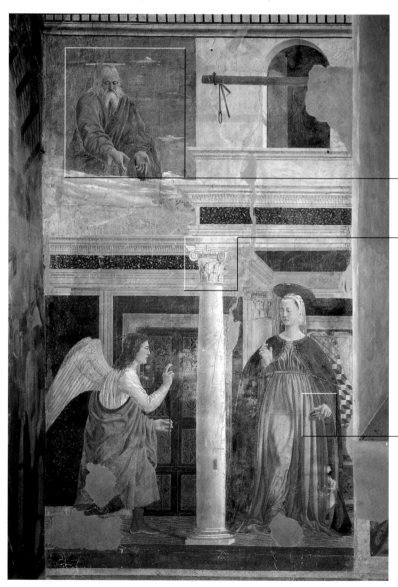

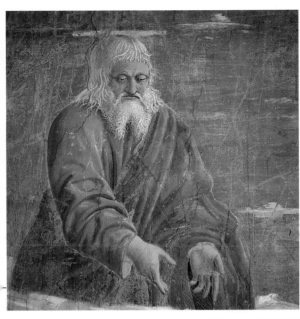

■ *The Annunciation* is a solemn and heavily symbolic work. However, it still follows a clear narrative path, as underlined by the sweeping, dramatic gestures of the characters. The presence of God on a cloud above the house of the Virgin Mary satisfies Piero's compositional requirements: the Father looks kindly on the two characters, and takes part in the event by releasing the Holy Spirit – depicted as golden rain – from his hands onto Mary.

■ This scene takes place in the porch of Mary's house. While the upper half of the building is simple, the lower half reflects a grandiose Renaissance taste. Piero inserts a series of magnificent decorations, of which the most striking are the inlaid door behind the archangel and the refined capitals that support the marble architrave of the porch. Although in general the geometric and perspective elements of this fresco are well balanced, there is one exception: the columns appear to be the same size as Mary and so reinforce the strength of her faith. Gabriel hands her not a lily, but a palm leaf, a symbol of life.

■ The Virgin Mary greets the messenger in a rather stiff pose that reveals her surprise, but also her humble acceptance. Behind her, an open door leads to a marble inlaid room, where a bed is visible. One of the most delicate details of this scene is the naturalistic way in which Mary holds her prayer book: she places it on her hip, and keeps a finger inside, so as not to lose her line. This balance between subtle allusion and affectionate description lies at the heart of the spiritual value of this scene, which is also a premonition of the Redemption.

BACKGROUND

In the painter's studio

Piero's frescoes have deteriorated over the course of time, and have been subjected to many repairs that have contributed to a distortion of his original work. The most accurate restoration enterprise began in 1989 and is still under way. Thanks to modern sophisticated research methods, the restorers have been able to identify Piero's unusual fresco technique. Although traditional frescoes are created by applying colors onto wet plaster, Piero also applied tempera on dry surfaces, white lead, and lake. His choice was probably dictated by the need to achieve specific chromatic and light effects, which are only obtainable on dry surfaces. Piero directed his studio with great care, and maintained a high level of control over all stages of the work. He personally executed the preparatory sketches used for the individual scenes of *The Legend*, a factor that explains the spectacular unity of the frescoes. During the execution, however, he gave his students a higher degree of autonomy, and their inexperienced hand can be seen in some episodes of the choral scenes. Two of Piero's assistants, Giovanni da Piamonte and Lorentino d'Andrea, however, played a significant role as they interpreted the master's advice in the light of their own highly personal style.

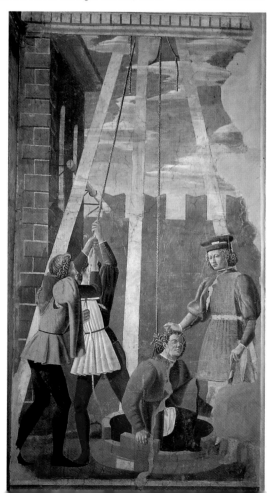

■ Giovanni da Piamonte, *The Torture of the Jew*, c.1459–64, Cappella Maggiore, San Francesco, Arezzo. Giovanni da Piamonte developed his skills during the Florentine Renaissance. Soon after being employed by Piero, he became his most trusted assistant: his master assigned him the episode immediately before the discovery of the Cross. This composition, centred around the wooden frame of the pulley, is located on the right-hand side of the crucifix.

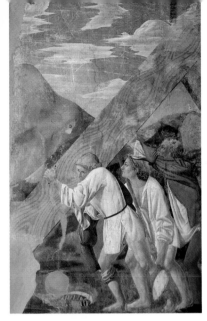

■ Giovanni da Piamonte, *Carrying the Sacred Wood*, c.1459–64, Cappella Maggiore, San Francesco, Arezzo. This scene portrays Jewish workers as they carry out Solomon's orders. The King of Israel demanded that the wood be buried after hearing the Queen of Sheba's prophesy that Christ would be crucified on that wood. Giovanni gave free rein to his narrative ability, especially in his portrayal of the men overwhelmed by the immense weight of the wood. Other notable details include the folds on the white clothes, and the curls and profiles of the subjects. The grain of the wood also seems to form an unusual pattern, circling the head of one of the men and so anticipating Christ's Calvary.

■ Lorentino d'Andrea, *St Louis*, c.1459–64, Cappella Maggiore, San Francesco, Arezzo. Lodovico d'Andrea was born in Arezzo. He had a humble birth, but overcame poverty by working relentlessly throughout his life. He operated mostly in his hometown and in the surrounding villages, and was one of Piero's most trusted students although not the most talented: Lorentino failed to translate his master's vibrant style into anything more than formulaic rules. Although this saint has a taste of Piero's monumentality, the violent light flattens its volume, and even the richly decorated attire fails to give it any spark. The figure appears all the more clumsy because of his unanimated expression.

Pouncing

Pouncing is a technique that ensures accurate preparation for a fresco. After executing the sketch on parchment, a series of holes is placed along the contours of the drawing to create a perforated pattern. The pattern is then placed on the plaster, and color powder filtered through the holes, creating a perfect trace upon which to paint the fresco. This example shows Leonardo's *Sketch for a Portrait of Isabella d'Este* (1500, Musée du Louvre, Paris).

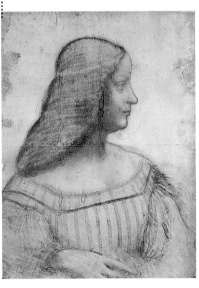

Piero and classicism

■ Below left: Piero della Francesca, *The Death of Adam*, detail, c.1459–64, San Francesco, Arezzo. This detail demonstrates Piero's anatomical knowledge. He can be considered one of the creators of Renaissance nudes: in his figures monumentality and expressive calm find a common ground.

Humanism coincided with a general rediscovery of antiquity which occurred only partly through literary works. Renaissance artists studied the art of the past in an active, conscious way: they were not interested in imitating it, but in drawing inspiration from it to create a new world based on the glory of the classical one. The competitive spirit that motivated them was best expressed by Alberti, who considered his contemporaries superior to both Greeks and Romans for being able to create a pictorial world without any guidance. A passion for collecting and trading in antiques also began to develop around this time: as a result, various artifacts came into circulation. Yet another stimulus came from the drawings and copies made by scholars such as Ciriacus of Ancona, who recorded their journeys through Greece in journals. Piero's stylistic refinement developed during his sojourn in Rome: after having visited the Eternal City, his figures gained a new depth that was inspired by the immortal creations of classical statuary.

■ Praxiteles (?), *Hermes and Dionysus*, Museum, Olympia. Classical sculptures combine harmonious proportions and naturalism, and have a subtly sensual appeal.

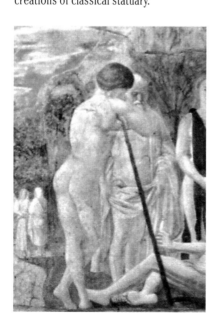

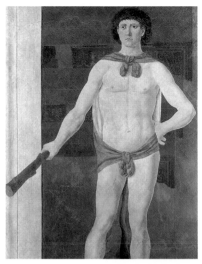

■ Piero della Francesca, *Hercules*, c.1465–70, Isabella Gardner Museum, Boston. This fresco originally decorated a room in Piero's family house in Sansepolcro. According to a scheme devised by Andrea del Castagno in Legnaia, the powerful figure is inserted within an architectural frame behind which another room opens. The young demigod has a noble, detached look, and he adopts the pose of a classical hero. Hercules rests a hand against one of his hips, which is slightly bent, in a naturalistic, reflexive manner. Hercules' strength is embodied by the club he carries in his right hand and which seems to project out of the picture. The tiny cloth of lionskin around the young man's hips barely covers his nakedness, emphasizing his virility. The light shines down on him, modelling the muscles that seem to almost burst through his skin, so giving the figure the seal of heroic beauty.

■ Piero della Francesca, *The Battle of Constantine*, detail, c.1459–64, San Francesco, Arezzo. During the Renaissance, there was a renewed interest in bas-relief. The composition of this fresco, reminiscent of a classical frieze, is crowded with a multitude of figures all on the same plane. Piero was probably inspired by a frieze he had admired in Rome.

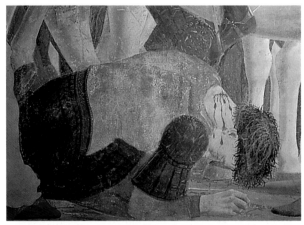

■ *Bas-Relief with Battle Scene*, Arch of Constantine, Rome. The scenes decorating this arch are justifiably famous. They narrate the story of the empire in suitably dramatic and impassioned tones. Some of the main scenes on the arch provided an important precedent for Renaissance artists in terms of battle iconography.

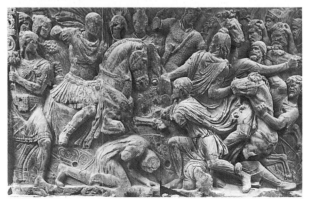

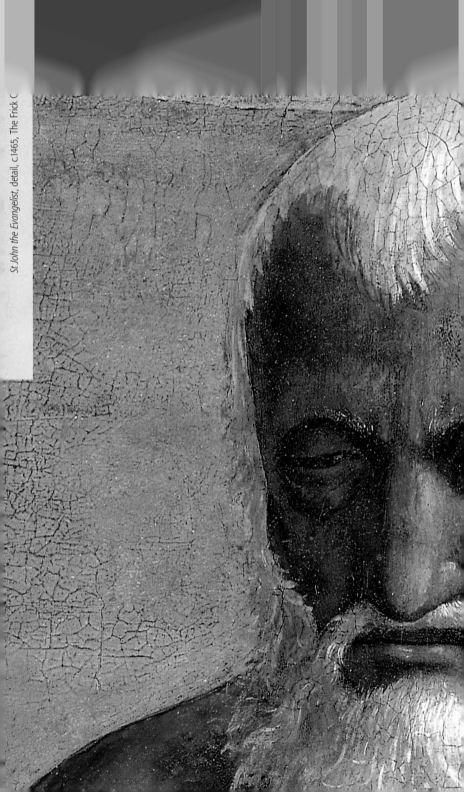

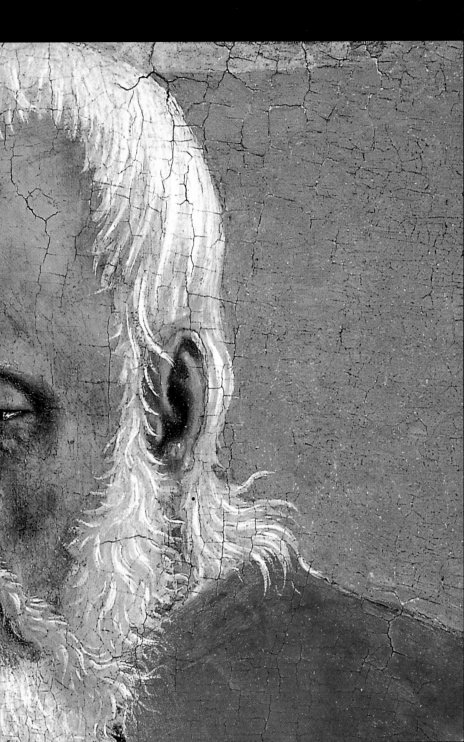

BACKGROUND

The Camerino School

Camerino in the 1400s was a small and provincial court in the upper Chienti valley. Its art school, however, was already well-established, and it experienced its most fertile period under the rule of the da Varano family. Before Federico da Montefeltro turned Urbino into a refined court and a place of cultural excellence, Camerino was the most important artistic centre in the region of the Marches. The younger artists from this small hill town often travelled to other places in central Italy and to Padua for inspiration. At about the same time, Piero was active in courts in the Apennines and the Adriatic. His work came to the attention of the Camerino artists who shared his preoccupation with perspective and light effects. Both Piero and the artists from the Camerino School are indebted to Domenico Veneziano. After spending some time in Padua and Florence with Giovanni Angelo di Antonio da Camerino, Giovanni Boccati executed his fresco cycle *Military Men* for the Ducal Palace of Urbino. In about 1450 the more talented Girolamo di Giovanni, together with the young Andrea Mantegna, created a series of frescoes in the Ovetari chapel in the Chiesa degli Eremitani in Padua – a city that became the most fertile centre of artistic growth in northern Italy.

■ Giovanni Boccati, *Military Men*, detail, c.1458–60, Appartamento della Jole, Palazzo Ducale, Urbino. This cycle of frescoes portrays warriors with idealized features and was probably executed in honor of the marriage of Federico da Montefeltro, Lord of Urbino, and Battista Sforza.

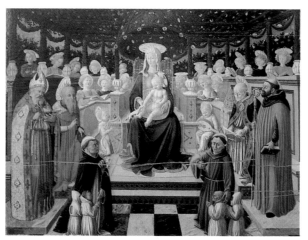

■ Giovanni Boccati, *Madonna of the Pergola*, 1447, Galleria Nazionale dell'Umbria, Perugia. This scene, framed by an arbor in bloom, is marked out by its unusual throne. The choir of angels is a delightful example of naturalism: two cherubs lean over the arms of the throne to catch a glimpse of the Child. Of the two angels by the throne, one focuses on his music, while the other one is entranced by the divine vision.

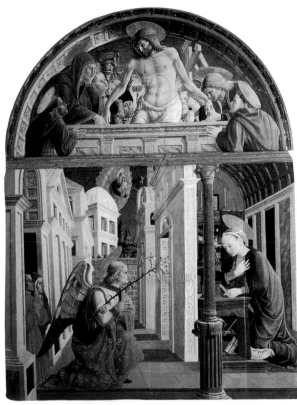

■ Girolamo di Giovanni da Camerino, *The Annunciation*, c.1455, Museo Diocesano, Camerino. Girolamo was a student in Giovanni Boccati's studio. While travelling to Padua in about 1450 he had the opportunity to study the innovations introduced by Piero, who, at the time, was working in Rimini and Ferrara. The result of his experiences can be observed in this work. Although devoid of Piero's analytical perspective, this painting contains some surprisingly modern architectural elements, such as the large arch depicting the commissioners of the painting and the Virgin Mary's room with its coffered vault. The scene is bathed in a strong light that emphasizes the architecture and the folds in Mary's cloak, and saturates the bright colors.

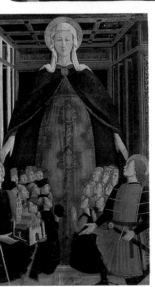

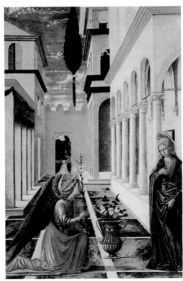

■ Far left: Girolamo di Giovanni da Camerino, *Madonna of the Misericordia*, 1463, Museo Civico, Camerino. Mary's fixed gaze and the position of the two saints at her feet recall Piero's *Polyptych of the Misericordia*. This remains, however, a simpler, less grandiose reading of the theme.

■ Giovanni Angelo di Antonio da Camerino, *The Annunciation*, c.1460, National Gallery of Art, Washington. This most enigmatic artist of the Camerino School was perhaps the Master of the Barberini Panels.

The Madonna del Parto

This fresco was painted in about 1465 for the high altar of the church of Santa Maria a Nomentana in Monterchi, not far from Sansepolcro. Recently restored, it is currently housed in the former village school there.

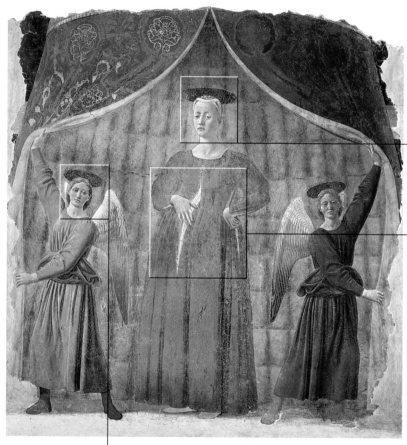

■ The parted canopy originally had a multicolored marble backdrop and a tiled floor, the existence of which is revealed in the reflections of the halos (left) of the two angels opening the curtains. These heavenly figures mirror each other, and it is likely that Piero painted them from a single pattern. They are smaller than Mary, and seem to advance towards the viewer: their intense gaze invites us to contemplate Mary and her pregnancy.

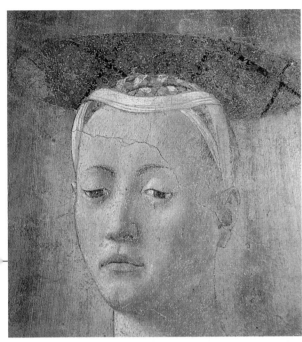

■ The splendid oval shape of the Virgin Mary's face is reminiscent of the *Madonna della Misericordia* and the handmaids of the Arezzo cycle. In this fresco, however, Mary's face is slightly asymmetric and reveals a sense of apprehension that climaxes in her distracted look beneath half-closed eyelids. Although isolated by her divine status, she is aware of her human predicament, and entranced by the mystery of Incarnation. The cult of Mary as the patron saint of pregnant women started in the Middle Ages: her painless delivery meant that she was in a position to protect women at a time when giving birth could often be fatal.

■ Mary wears a simple blue dress that indicates the plain fashion of the time. The front of her dress is open to reveal a white tunic, a hint to the Immaculate Conception. The three-quarter pose successfully combines regality and naturalism. With masterly delicacy, Piero places the emphasis on Mary's condition by portraying her as she places with a natural gesture , one hand on her belly, and the other on her hip, in a position that underlines the heaviness of her body. The human touches brought by Piero to the maternity of the Virgin have made this fresco a popular image.

BACKGROUND

Contemporary developments

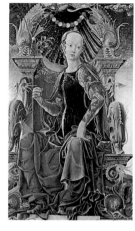

W̶hile Piero was developing his art, Padua became established as the centre of Renaissance ideals in northern Italy. Fundamental to the city's new position was the long sojourn of Donatello (1444–53) who was eagerly welcomed by local scholars, many of whom had a keen interest in classical literature. Andrea Mantegna flourished within this environment: he was familiar with the classics, but also interested in Donatello's new ideas on perspective. Mantegna's powerful personality can be observed in the frescoes portraying the lives of Saints James and Christopher in the Chiesa degli Eremitani. Although most of the frescoes were destroyed during World War II, one can still witness the monumentality of the compositions, which are made even more solemn by the accuracy of the archeological references. The architectural elements in Mantegna's grandiose scenes reveal his interest in perspective, an interest that often led him towards illusionism. His works and Donatello's reliefs on the high altar of the Basilica di Sant'Antonio attracted to Padua a generation of artists who contributed to the expansion of new artistic elements throughout the whole of northern Italy, from Milan and Venice to Ferrara.

■ Cosmé Tura, *Erato*, c.1460, National Gallery, London.

■ Below left: Vincenzo Foppa, *A Miracle of St Peter Martyr*, 1464–68, Sant'Eustorgio, Milan. This work combines delicate light effects and architectural rigor.

■ Giovanni Bellini, *Transfiguration*, 1455, Museo Correr, Venice.

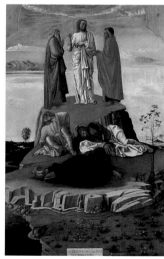

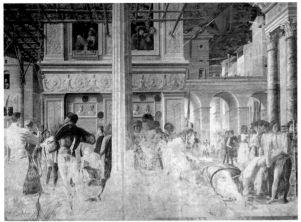

■ Andrea Mantegna, *The Martyrdom of St Christopher*, 1457, Cappella Ovetari, Chiesa degli Eremitani, Padua. The scenes of the martyrdom and transportation of St Christopher's body take place within an urban setting that is the ideal continuation of the architecture of the chapel. The pergola extends back into the painting, guiding the viewer towards the cruel torture of the saint whose eyes are pierced by a spear.

■ Andrea Mantegna, *St Zeno Altarpiece*, 1457–59, San Zeno, Verona. The complex structure of this work was inspired by Donatello's reliefs on the high altar of the Basilica di Sant'Antonio in Padua and, in turn, influenced the way in which altarpieces were subsequently created in northern Italy. The *sacra conversazione* is located within a thick wooden frame which is taken up by the architectural elements of the painting. The scene takes place in an open gallery divided by columns and decorated with fruit garlands. The foreshortening of the figures takes the viewer's low observation point into consideration, and helps to create a feeling of involvement.

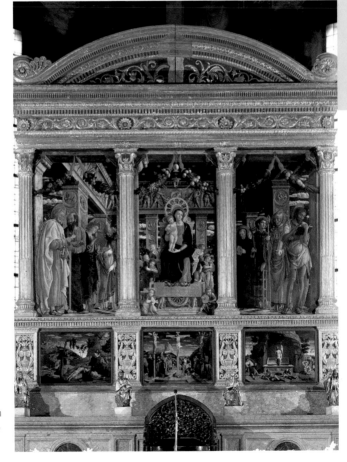

1465–1474

The Resurrection

This fresco was probably executed in about 1467–68 for the Hall of Ceremonies in the Palazzo dei Conservatori in Sansepolcro, known today as the Museo Civico. It was subsequently moved to a different wall, where it still remains.

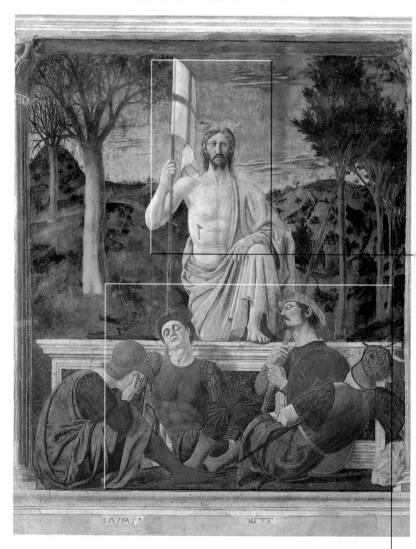

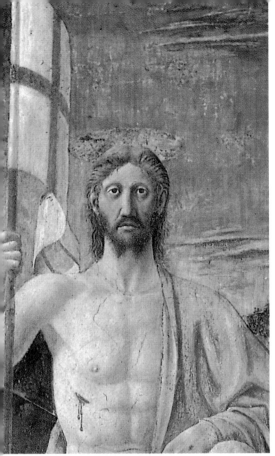

■ Leon Battista Alberti, Temple of the Holy Sepulchre, Palazzo Rucellai, Florence.

■ The bodies of the sleeping soldiers by the sepulchre seem to make the most of the limited space. The two central figures rest their heads on the banner and the spear, directing the gaze of the viewer towards the focal point of the scene.

■ Christ strides out of the sepulchre in a powerful, majestic way, and his attitude suggests a triumph over death and sin rather than a return to earth. Christ is wrapped in a richly folded pink tunic that supports his regal status, and the anatomical details of his body are highlighted by the cold light of dawn. The idea of salvation is rendered by the nature in the background: where once were bare trees, an eternal spring seems now to have taken hold.

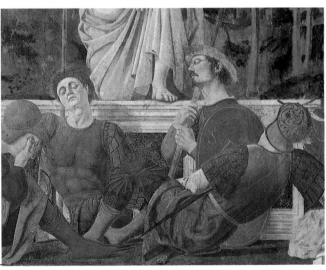

Perugia

■ Bartolomeo Caporali,
*Madonna with Child
and Angels*, c.1460,
Galleria degli Uffizi,
Florence. This
affectionate pose is
rendered with brilliant
colors and subtle tones.
The angels at the side
of the throne seem to
have maintained the
sinuous pose typical
of Gothic figures.

In the mid-15th century Perugia slowly shed its traditional, archaic culture and opened up to the new Florentine influences. This transition may never have taken place had it not been for the presence in the city of Fra Angelico and Domenico Veneziano, who was working for the Baglioni family. Thanks to its geographical location, Perugia was the crossroads of the new developments in central Italy even before Piero della Francesca's arrival, as proven by Giovanni Boccati from Camerino, who executed his *Madonna of the Pergola* for the Brotherhood of San Domenico. The local art school, which had previously been inspired by Gothic movements, especially from Siena, underwent a change of direction. Its main representatives, Benedetto Bonfigli and Bartolomeo Caporali, developed a bright, graceful style perfectly suited to the devotional themes of their works. Thanks to the bridge at Urbino, Perugia also received many influences from artistic schools on the Adriatic coast: after completing the Tempio Malatestiano in Rimini, Agostino di Duccio moved to Perugia, where he created the facade of the Oratory of San Bernardino, one of the most innovative buildings of the time. In this work, he combined devotional elements and civic pride.

■ Benedetto Bonfigli,
*The First Siege of
Sant'Ercolano*, detail,
1454–61, Galleria
Nazionale dell'Umbria,
Perugia. During the
1450s Perugia witnessed
political tumult among
the noble families.
The indirect result was
an increase in artworks
celebrating civic values.

■ Benedetto Bonfigli, *Annunciation and St Luke*, c.1455–60, Galleria Nazionale dell'Umbria, Perugia. This work was commissioned for the audience chamber of the College of Notaries in Perugia. Great attention was paid to the decorative details, as revealed by the marble ornaments and the wooden fretwork in the upper gallery. The graceful poses of the figures are reminiscent of Fra Angelico's characters. The scene has a distinctly narrative flavor: the archangel Gabriel visiting Mary seems surprised by the presence of St Luke in the centre. In an explicit allusion to the legal profession, the saint busies himself drawing up a report on parchment.

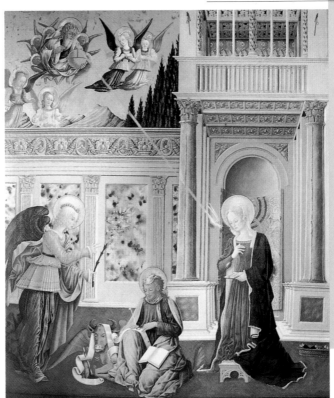

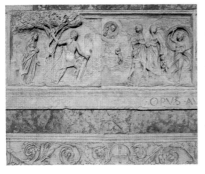

■ Agostino di Duccio, *San Bernardino Rescues a Child Fallen in the River and Carried by the Current under the Vanes of a Mill*, 1457–61, Oratory of San Bernardino, Perugia.

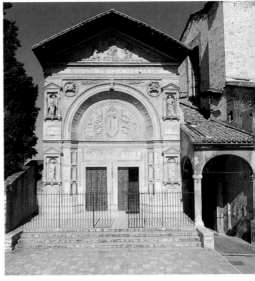

■ Agostino di Duccio, facade of the Oratory of San Bernardino, 1457–61, Perugia. San Bernardino and symbols of the city are depicted on this facade, hinting at the building's civic value.

Polyptych of St Antony

This monumental altarpiece was created in about 1467–68 for the church of St Antony, which belonged to the female order of the Franciscan Tertiaries in Perugia. It is currently housed in the Galleria Nazionale dell'Umbria.

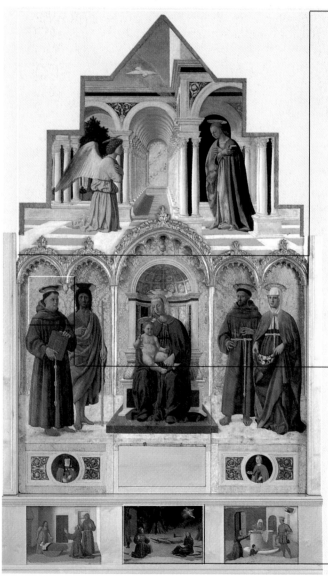

■ Filippo Brunelleschi, outer colonnade, San Sepolcro, Florence.

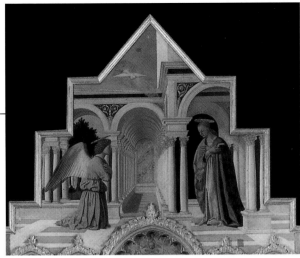

■ *The Annunciation* is the only section of this complex polyptych that is attributed solely to Piero. The event is depicted in a calm, gentle manner: Mary has already been given the divine message, and seems ready to receive the Incarnation. The archangel remains kneeling after having spoken to Mary, although the figures both appear almost isolated within their individual roles and emotions, a fact that is emphasized by the foreshortened colonnade in the background. The atmosphere of expectation is highlighted by the chiaroscuro of the portico and the quasi-supernatural light reflecting off the white marble.

■ The intervention of Piero's assistants is evident in the central section of the altarpiece. However, it is likely that St Antony's face was painted by Piero himself, as revealed by the solid, shapely masses which were the artist's trademark. The reflection of the saint's tonsured head in his halo is an exquisitely realistic detail, and proof of Piero's virtuosity.

■ The three scenes on the predella are episodes from the lives of saints inspired by popular Franciscan tradition. They form the liveliest narrative element of the altarpiece. In the central panel *The Stigma of St Francis*, the emotion of a miracle is made more tangible by the divine light emanating from the small figure of Christ: surrounded by a golden dust, Jesus breaks the darkness of the night sky.

Pietro Perugino's captivating synthesis

Piero's new innovations found fertile ground in Perugia, where they inspired a pictorial style that bred many important artists. One of them was Pietro Vannucci, whose career became so closely associated with the Umbrian city that he was nicknamed Perugino. Not much is known about his formation but in the 1470s he gained notoriety thanks to a winning synthesis of traditional elements with recent innovations in perspective. The artistic director of a busy studio, Perugino combined his love for simple forms with Piero's sobriety, developing an elegant, gentle style that soon became widely fashionable. After studying in Verrocchio's studio in Florence, Perugino was invited by Pope Sixtus IV to Rome, where he took part in decorating the Sistine Chapel along with Luca Signorelli, Pinturicchio, Domenico Ghirlandaio, and Sandro Botticelli. This experience was to mark the beginning of his successful career, and he was subsequently invited to many courts all over Italy. Raphael, one of Perugino's students, developed his master's slightly static classicism and went on to become a major exponent of the High Renaissance.

■ Palazzo dei Priori, c.1200, Perugia.

■ Pietro Perugino, *The Giving of the Keys to St Peter*, 1481–82, Musei Vaticani, Sistine Chapel, Rome. An extraordinary perspective is used for this image of the investiture of the first pope. The building in the centre of the piazza is an ideal synthesis of Renaissance elements.

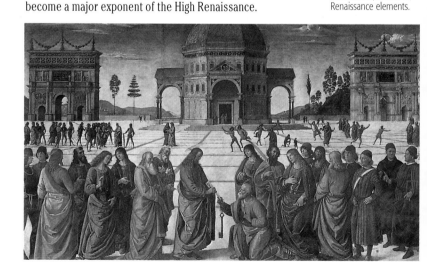

■ Master of 1473 and Pietro Perugino, *The Healing of a Young Girl*, 1473, Galleria Nazionale dell'Umbria, Perugia. This is one of eight panels portraying the life of St Bernardino originally meant for the Oratory. The work as a whole was designed by an artist who had clearly been influenced by contemporary architectural developments. Other painters, including Perugino, helped him in this work. The balance of this scene is typical of the Umbrian master: the tiny figures looking onto a calm landscape are placed in a semi-circle before a tall arch. The brightness of the interior is contrasted by the twilight in the background.

■ Below: Pietro Perugino, *The Adoration of the Magi*, c.1475–76, Galleria Nazionale dell'Umbria, Perugia. This is considered the first oil painting of the Umbrian school. Perugino uses a range of bright colors barely touched by the light shining on the landscape.

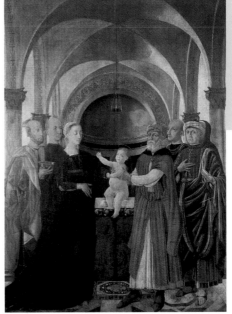

■ Follower of Piero della Francesca (Pietro Perugino?), *The Presentation of Jesus in the Temple*, c.1470, Private Collection. The insertion of characters within a clearly defined architectural structure and the pervasive calm of the atmosphere suggest the style of Piero's frescoes in Arezzo. According to a recent theory, this could be one of Perugino's first paintings. Although little is known about the artist's development, it is quite possible that he was already familiar with the works of Piero della Francesca when he began his career.

BACKGROUND

Italian courts

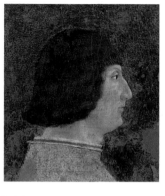

■ Zanetto Bugatto (?), *Portrait of Galeazzo Maria Sforza*, c.1465–68, Castello Sforzesco, Milan. Bugatto was Galeazzo Sforza's favorite portrait artist. He spent three years in Brussels, where he worked in Rogier van der Weyden's studio.

The emergence of numerous Renaissance courts in the 15th century had a profound impact on the diffusion of art. Relations generally remained friendly between the courts as they continued to compete for political, territorial, and cultural supremacy. During Lorenzo the Magnificent's rule of Florence (1469–92), the function of art became less public and more reliant on private patronage. Mantua, on the other hand, became one of Italy's leading courts under the guidance of Ludovico II Gonzaga (1444–78), who assigned the cultural renewal of the city to Leon Battista Alberti and Andrea Mantegna. Ludovico established such a good rapport with Mantegna that he named him personal advisor and curator of his prestigious art collection. Under the rule of Borso d'Este (1450–71), Ferrara also became known as one of Italy's most lively courts: the artists invited here created a series of refined and ceremonial works known as the "delights". When the Sforza family came to power, Milan also started to consider new cultural directions: the city witnessed the developing skills of Bramante and Leonardo, who turned the Lombard court into a cradle of experimentation.

■ Ducal courtyard, Castello Sforzesco, Milan. The Lombard duchy did not witness a continuous process of artistic renewal. Although the Sforza family welcomed the artistic innovations from central Italy, it did not immediately discard the Gothic tradition. The Cappella Ducale in the castle was completed in 1473 and is decorated with frescoes on a golden background by an unknown Gothic artist.

■ Francesco del Cossa, *April*, detail, 1468–69, Palazzo Schifanoia, Ferrara. This allegory of the calendar months represents the climax of the intellectual and flattering style promoted by Borso. The Duke is portrayed giving a coin to a jester.

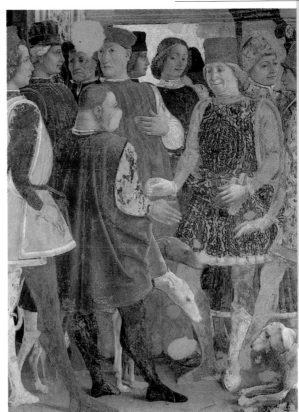

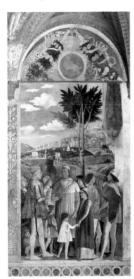

■ Andrea Mantegna, *The Meeting of Ludovico Gonzaga and his Son Cardinal Francesco*, detail, 1465–74, Cappella Ducale, Camera degli Sposi, Mantua. The solemnity of the style derives from the clear masses of the figures and the bright light.

■ Sandro Botticelli, *Madonna of the Magnificat*, 1483–85, Galleria degli Uffizi, Florence. Botticelli created an optical experiment: the circle within which the painting is contained acts as a convex mirror.

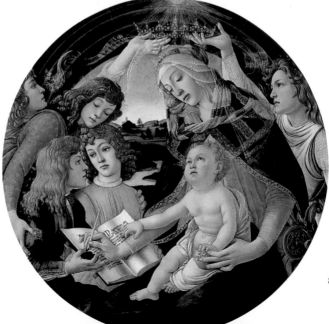

Federico da Montefeltro

Urbino deserves a special mention among the many Italian courts of the 15th century. A small town in the Apennines of the Marches, Urbino became one of the most fertile centres of the Renaissance under the rule of Federico da Montefeltro, who transformed it into the capital of intellectual and mathematical arts. Federico was the illegitimate son of Guidatonio da Montefeltro. He was educated far from Urbino, living for 15 months in the cosmopolitan climate of Venice and then in Mantua for two years. He was a guest of the Gonzaga family, and was educated in Vittorino da Feltre's "joyous house". Vittorino was a humanist who had developed an innovative teaching method that rejected sterile academic notions. Many noble young men were attracted to his school. In the space of a few years, Federico became an astute warrior who placed his military cunning at the service of whomever requested it. Suddenly, in 1444, he came to power following the death of his 17-year-old step-brother Oddantonio, who was allegedly killed during a feud. In actual fact, it is likely that Federico himself was somehow implicated in Oddantonio's death: the latter had recently married, and any potential offspring would certainly have prevented Federico from ever becoming Lord of Urbino.

■ Courtyard of the Palazzo Ducale in Urbino. The ducal palace, started in 1447 and built over a 20-year period, is the most significant work of the Renaissance in Urbino.

■ The palace includes pre-existing medieval buildings and stretches along the slopes of the hill, connecting the city on top to the market square and the countryside below.

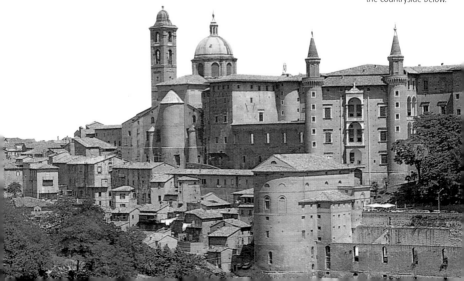

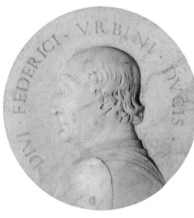

■ Gaspard van Wittel, *View of Urbino*, 1723, Villa dell'Imperiale, Castelbarco Albani Collection, Pesaro. The Ducal Palace expressed the ideals of moral and aesthetic perfection that animated Federico. Urbino has remained a fascinating centre throughout the centuries, and still attracts many tourists.

■ *Federico da Montefeltro and Cristoforo Landino*, from Cristoforo Landino, *Disputationes Camaldulenses*, Ms Urb. lat. 508, Biblioteca Vaticana, Rome. Federico was patron to many literary men such as the Latinist Landino, and Vespasiano da Bisticci, who helped him to create his library.

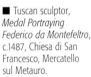

■ Tuscan sculptor, *Medal Portraying Federico da Montefeltro*, c.1487, Chiesa di San Francesco, Mercatello sul Metauro.

An eclectic environment

Official documents date Piero's first sojourn in Urbino as 1469. In that year the Brotherhood of the Corpus Domini asked him to complete an altarpiece that had been started by Paolo Uccello, who had only created the predella. Piero's first encounter with the Montefeltro court may have happened prior to the recorded date. It is around the end of the 1460s, however, that Federico began his project of patronage aimed at transforming the city into an international centre of cultural attraction. In 1466 Federico gave the Dalmatian architect Luciano Laurana complete authority over the works in the Ducal Palace: the result was the most typically Renaissance section of the building. After 1472 the project was assigned to Francesco di Giorgio Martini from Siena, who also erected the fortifications around Urbino. Between 1472 and 1476, two foreign artists resided at Federico's court: the Flemish Joos van Ghent and the Spanish Pedro Berruguete. Their presence contributed to the inclusion of refined pictorial solutions within the Italian culture of perspective, and to the creation of a style unique to the Renaissance in Urbino.

■ Francesco Laurana, *Bust of Battista Sforza*, c.1472, Museo Nazionale del Bargello, Florence. This sculpture portrays Federico's second wife. It was probably created after Battista's premature death using a funeral mask, which was designed to exalt the ethereal beauty of the sitter.

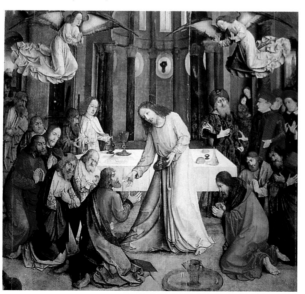

■ Joos van Ghent, *The Communion of the Apostles*, 1472–74, Galleria Nazionale delle Marche, Urbino. Called to Urbino by Federico himself, who was a great admirer of oil paintings, van Ghent ended up painting the altarpiece for the Brotherhood of the Corpus Domini that had been previously offered to Piero. This work, however, is not one of his masterpieces: van Ghent had never worked with such a large altarpiece, and in order to deal with the difficulties of composition he resorted to a tight semicircular composition and disproportionate figures.

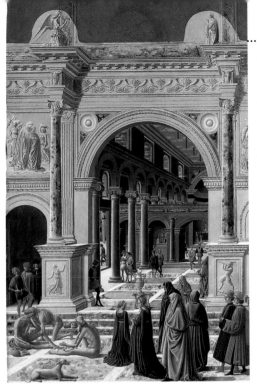

An enigmatic artist

Master of the Barberini Panels, *The Presentation of the Virgin in the Temple*, c.1460, Museum of Fine Arts, Boston. The artist who executed this work is sometimes identified as Giovanni Angelo di Antonio from Camerino, or as the mysterious Fra Carnevale who was especially active around Urbino. Whatever his real identity, this painter managed to successfully convey the rarefied cultural climate of the Montefeltro court: the tiny figures are not affected by the solemn architectural structures that dominate the scenes and so create a quasi-supernatural silence.

■ Paolo Uccello, *The Miracle of the Host*, predella of the *Corpus Domini Altarpiece*, 1467–68, Galleria Nazionale delle Marche, Urbino. Uccello was quite old when he painted this work. Here he describes a fantastical narrative sequence.

■ Francesco di Giorgio Martini, San Bernardino, interior detail, 1483–91, Urbino. Francesco's style derives from the combination of highly formal elements: the frieze around this inscription is brought to life by the white plaster of the wall.

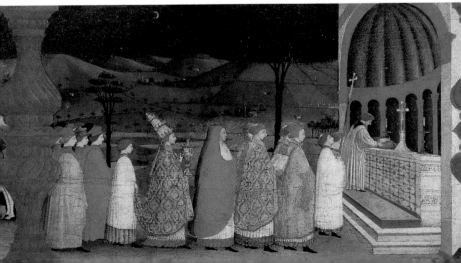

The Flagellation

The history of this small painting is still the subject of much research and speculation. It was probably realized between 1460 and 1465 in Urbino, where it is still housed at the Galleria Nazionale delle Marche.

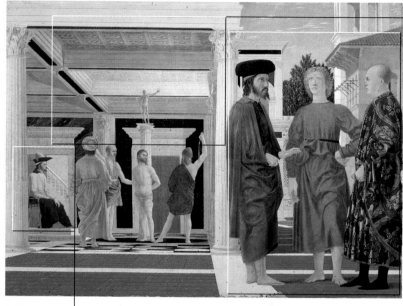

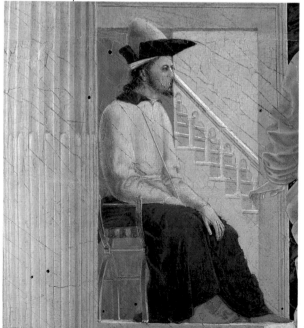

■ The flagellation takes place in a classical open gallery defined by Piero with impressive linear perspective. The architecture of the interior is marked by the marble tiles on the floor and the series of lateral columns. On the left-hand side of the painting Piero has omitted two columns to create an alcove for the man witnessing the cruel event. The man on the seat, however, is not Pontius Pilate, but the Byzantine emperor, as revealed by the cut of his clothes and the unusual headgear with upturned brims.

■ A diffused light creates delicate effects on this golden statue, symbol of the god of the sun. The coldness of the light contributes to an unsettling effect that gives this sacred scene a timeless, universal dimension.

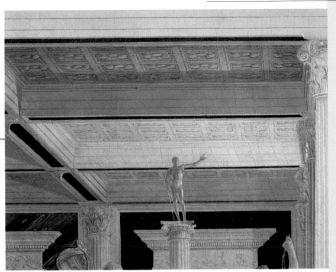

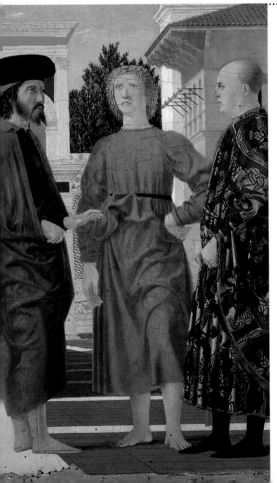

A painting and its legend

The Flagellation is one of the most mysterious of artworks and, as such, has warranted a great deal of study. Who are the three characters in the foreground? And, since they pay no attention to the events in the gallery, what kind of rapport do they have with that part of the narrative? The work was probably inspired by the projects of a crusade against the Turks: after the fall of the Byzantine empire, the western world was eager to defend the Christian faith. The torture of Christ symbolizes the suffering of the church. Although they may never be properly identified, the three men in the foreground were probably contemporary figures somehow involved in Pius II's crusade projects. Their perfectly still presence has fascinated viewers throughout the centuries, in particular the man with the beard who Piero has painted as one of the most intense of Renaissance portraits.

BACKGROUND

A princely microcosm

Within the Ducal Palace in Urbino is a small room, the "studiolo", situated between the private apartments and the public halls. It was here that Federico used to retire to whenever his busy diplomatic and military life allowed him the time. The complex decoration in this room appears to reflect the convoluted intellectual itinerary of its commissioner. The walls are divided into two sections: the lower section is decorated with magnificent wooden inlays, while the upper one, which used to contain 28 portraits of illustrious men, was probably executed by Joos van Ghent and Pedro Berruguete. The portraits included both lay and Christian characters in a humanistic combination of pagan and religious spirituality. The decision to mix poets and philosophers with politicians and statesmen is also symbolic of Federico's own winning synthesis of active and contemplative life, upon which his rule was based.

■ Benedetto da Maiano (attributed to), *Intarsia with Armor*, c.1472–76, Studiolo, Palazzo Ducale, Urbino. In this section a shining suit of armor hangs in its individual parts in the wardrobe. It is almost as if Federico had just taken it off to read a book, which is also rendered in a trompe-l'œil fashion on the walls of the studiolo. The base of the wardrobe is very similar to the one painted by Piero in the *Brera Altarpiece*.

■ Benedetto da Maiano (attributed to), *Intarsia with Perspective*, c.1472–76, Studiolo, Palazzo Ducale, Urbino. The art of wood inlaying was extremely popular at the Montefeltro court. Indeed, the intellectual climate of Urbino was well suited to the strong abstraction typical of this art form. In this particular inlay, the cornice frames an urban landscape: on the ledge are a basket of fruit and a squirrel, who is busy nibbling a nut. Beyond these foreground elements are a paved porch and a splendid gallery of arches, behind which is a delightful hilly view. A lake is also in the background. The vibrant color effects, achieved by the careful positioning of individual pieces of walnut wood cut in different ways, contribute to the charm of this work.

1472: a fateful year

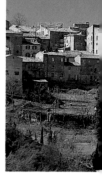

In 1472 the life of Federico da Montefeltro and the destiny of the court of Urbino underwent a dramatic change. In January that year Battista Sforza, Federico's wife, gave birth to an eagerly-awaited son, named Guidubaldo, probably as a result of a votive offering to Saint Ubaldo. Battista was the daughter of Alessandro Sforza, Duke of Pesaro and a lifelong friend and political ally of Federico. Federico's and Battista's wedding had taken place in 1460, and, although the alliance was originally meant to strengthen the rapport between the two families, it turned out to be a happy and loving union. During her time as Duchess of Urbino, the lively and intelligent Battista had proved more than able to represent her husband and his court during his many absences. Guidubaldo's birth as heir to the throne was made even more special by the fact that Battista had had eight daughters, two of whom had died prematurely. A few months later, however, while the Duke of Urbino was in Florence celebrating the city's capture of Volterra, he was informed that his wife was seriously ill. He hastily returned to his court to spend a few final moments with Battista, who died of pneumonia aged only 26 years old.

■ The Medici family, who were interested in the rich mineral deposits in and around the small republic of Volterra, employed Federico's military cunning to capture the city on behalf of Florence.

■ Coat of arms with the eagle of the Montefeltro family in a blazing sun. Federico's ascent seemed to know no limits: in 1462 Pius II nominated him Gonfalonier of the church, thereby giving him full command of the Christian army.

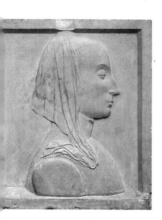

■ Francesco Laurana (?), *Battista Sforza*, c.1460–70, Museo Civico, Pesaro. This marble bas-relief provided the model for all subsequent portrayals of Federico's wife.

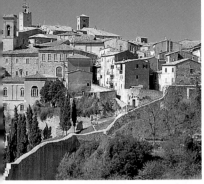

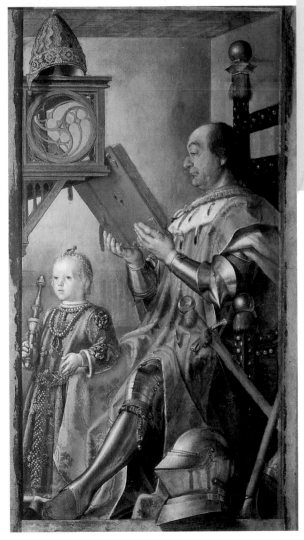

■ Pedro Berruguete, *Federico da Montefeltro with his Son Guidubaldo*, c.1476–77, Galleria Nazionale delle Marche, Urbino. Federico was made Duke in 1474. In this painting he reads a book while wearing his armor. His military and diplomatic talents earned him the two main awards of the time: the Order of the Ermine, created by the king of Naples, and that of the Garter, given by the king of England to a select number of people. Federico is seen wearing the symbols of both orders, while Guidubaldo holds the sceptre.

■ Joos van Ghent, *The Communion of the Apostles*, detail, 1473–74, Galleria Nazionale delle Marche, Urbino. Battista, a religious woman who was always sensitive to the problems of her subjects, was not forgotten after her death. Indeed, many artists continued to include her in their works. In this painting, she is holding a young Guidubaldo, a detail probably suggested by Federico himself, who is also present.

A new phase

BACKGROUND

■ Below left: Bernardo
Prevedari (after Bramante),
Perspective View, c.1481,
Civica Raccolta di Stampe
Bertarelli, Milan. This
engraving represents an
architectural structure
similar to that of the
church of San Bernardino,
and reflects Bramante's
development in Urbino.

■ Luciano Laurana,
side of the small
towers, Palazzo Ducale,
c.1470–72, Urbino.
This aspect, dominating
the valley, is the best
testimony of Laurana's
talents and contribution
to the palace.

The birth of Guidubaldo coincided with a new direction in Federico da Montefeltro's artistic patronage. Architect Luciano Laurana was fired in 1472 and, as a result, work on the Ducal Palace was interrupted. The Lord of Urbino was no longer focused on the palace, but intent on keeping a vow made upon the birth of his heir: of erecting a new family mausoleum. For several years Federico had been thinking about building a family tomb for himself and his descendants and, indeed, there were plans for a funeral chapel within the palace. The birth of his son, however, persuaded him to commission Francesco di Giorgio Martini, who had also designed the Duomo of Urbino, to build the Franciscan church of San Bernardino just outside the city walls. It is for this mausoleum that Piero's *Brera Altarpiece* was meant. It is probably not a coincidence that the church of San Bernardino is located on a hill facing the convent of Santa Chiara, where the pious Battista Sforza was buried in a mass grave, as she had wished. It seems that the couple, much as they do in Piero's *Diptych*, maintained some kind of dialogue even after her death.

■ Internal view of San Bernardino, c.1477–91, Urbino. Francesco di Giorgio designed the church so that it would incorporate the pre-existing church of San Donato where Federico's father was buried. The simplicity and purity of the structure indicate the Franciscan spirit and are suited to the main function of the church as family mausoleum.

■ Raphael, *Small Cowper Madonna*, detail showing the church of San Bernardino, c.1505, National Gallery of Art, Washington.

■ A study of Piero's *Brera Altarpiece* shows the similarities between the architectural structure created by the Tuscan artist and the church of San Bernardino.

MASTERPIECES

The Brera Altarpiece

This altarpiece was executed between 1472 and 1474, possibly for the church of San Donato degli Osservanti in Urbino. It was later moved to the church of San Bernardino, and is today kept in the Pinacoteca di Brera in Milan.

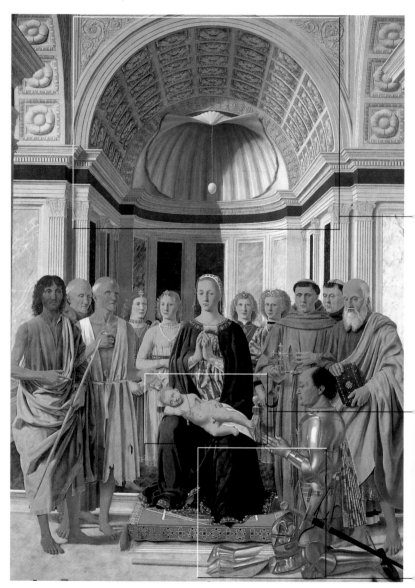

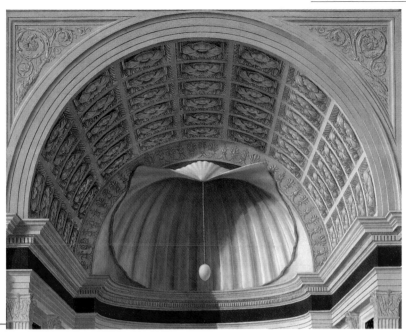

■ The sumptuous apse is decorated with colored marble and covered by a coffered vault decorated in the Renaissance style. In the apse is a shell from which hangs an ostrich egg on a length of chain. This element focuses the attention of the viewer and is symbolic of the several meanings of the work: the egg hints at the birth of Christ, but also at that of Guidubaldo, a birth that guaranteed dynastic continuity for the Montefeltro family.

■ The celestial court of saints and angels grouped in a semi-circle around the Virgin Mary gives the scene a noble tone. The centre of the painting, however, is the sleeping child, who is completely relaxed on his mother's knees. His round body and luminous skin barely touched by shadows give the whole a sense of serenity and holiness.

■ This painting was commissioned by Federico da Montefeltro. It was meant to serve a public function, while at the same being relevant to the private history of the family. Federico is wearing his armor and, as a sign of humility, has laid his helmet, gauntlets, and staff on the floor. Piero's usual attention to detail can be seen in Federico's dented helmet, which reflects a deformed image of the Duke.

The ideal city

■ Below: Attributed to Luciano Laurana, *View of an deal City*, c.1470, Galleria Nazionale delle Marche, Urbino. This painting of an imaginary Renaissance city serves as an ideal manifesto of developments in linear perspective.

Τhe second half of the 15th century witnessed an increasing interest in Platonic and Aristotelian texts, especially those that contained important directions on the art of good government. These writings also influenced the new lords of cities and courts, who were trying to establish some kind of political stability within their domains. Inspired by the new humanistic ideals of political balance, the rulers also took into

■ Bottom: Francesco Borgianni, *Madonna and St Francis with the City of Mantua in the Background*, detail, c.1600–10, Palazzo Ducale, Mantua.

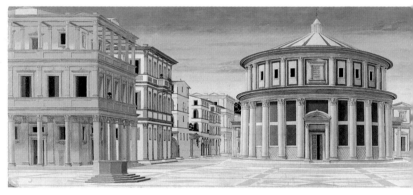

consideration urban problems. It is from this new agenda that the myth of the ideal city was born. The process of social and ideological renewal begun in Florence was mirrored by one in the territories and in the smaller cities. Again, Urbino became a role model by playing host to the main architects and philosophers of the time, from Leon Battista Alberti to Marsilio Ficino. Mantua also began a programme of urban renewal. However, in the court ruled by the Gonzaga family, this programme did not extend to the whole city, but focused on individual buildings, especially the Ducal Palace. This construction became a citadel isolated from the old civic centre, a fact that underlined even visually the power of the Gonzaga family over the city.

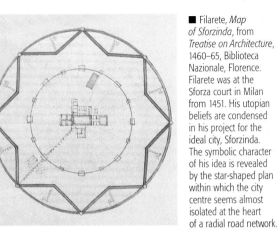

■ Filarete, *Map of Sforzinda*, from *Treatise on Architecture*, 1460–65, Biblioteca Nazionale, Florence. Filarete was at the Sforza court in Milan from 1451. His utopian beliefs are condensed in his project for the ideal city, Sforzinda. The symbolic character of his idea is revealed by the star-shaped plan within which the city centre seems almost isolated at the heart of a radial road network.

■ View of the Pienza's Piazza. Pope Pius II promoted the urban renewal of his birthplace, Corsignano, which he subsequently renamed Pienza. The transformation of the village into a modern Renaissance town was assigned to Bernardo Rossellino in 1459. The plan focused on the main square, for which Rossellino designed the cathedral, the town hall, Palazzo Piccolomini, and Palazzo Borgia.

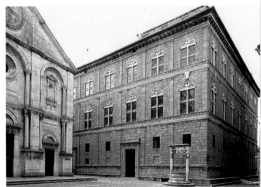

■ The unusual trapezoidal shape of the Piazza in Pienza derives from the attempt to integrate new Renaissance elements within the existing fortified centre. Indeed, even today the latter maintains its medieval radial structure next to the fifteenth-century piazza. The urbanistic development in Pienza was the only attempt to put into practice Renaissance ideologies. Unfortunately, the death of Pope Pius II in 1464 meant that it was never completed.

The Diptych of the Uffizi

This painting was commissioned by Federico da Montefeltro in about 1474. Originally the tablets, painted on both sides, were joined by hinges so that they could be closed like a book. The work is kept at the Galleria degli Uffizi in Florence.

■ On the front of the left tablet, Federico requested Piero to portray his wife, Battista Sforza, who had died at a young age. This diptych is the Duke's posthumous heartfelt homage to his beloved wife, in memory of their all-too-brief happiness. Battista is presented in profile in front of a hilly landscape seen from a higher position. She is wearing a richly decorated dress, and her pale face is framed by a sophisticated hairstyle kept in place by a jewel. On the back of her head is a white veil that reflects the light by creating a subtle play of folds.

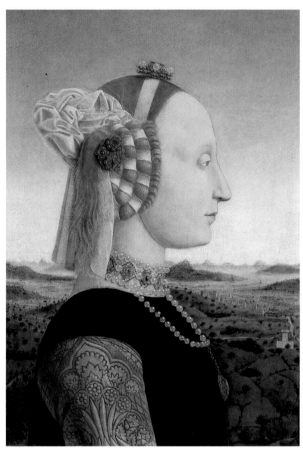

ARVS INSIGNI VEHITVR TRIVMPHO ·
VEM · PAREM SVMMIS DVCIBVS PERHENNIS ·
MA VIRTVTVM CELEBRAT DECENTER ·
EPTRA TENENTEM ··

■ The backs of the tablets are decorated with two triumphal chariots. At the bottom of this painting is a Latin inscription praising Federico's military talents. The chariot on which the Duke is sitting moves along a rocky terrain, behind which is a still lake and landscape covered by the morning mist. The Virtues accompanying him underline his qualities: Fortune, about to crown him; Justice, with a sword and a set of scales; Fortitude, carrying a broken tower; and Temperance.

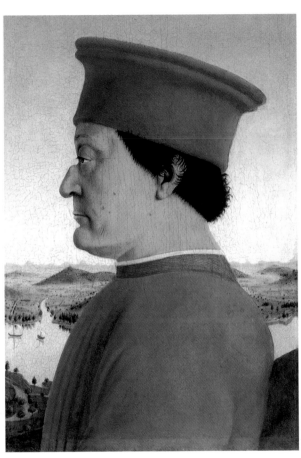

■ Federico is portrayed with brutal realism: on the side of his eyes and on his cheeks, the Duke's dark skin is crossed by numerous lines. His profile is unmistakably characterized by his aquiline nose: the Duke of Urbino had broken it as a young man, in a tournament during which he had also lost his right eye. He is wearing his red ducal clothes, and the geometric purity of his cylindrical headgear is emphasized by the light blue background. In this portrait, as in the one of Battista, Piero combined realism with a strong sense of formal abstraction to place the sitter in a sphere of superior dignity.

■ Battista's triumphal chariot is meant to highlight her moral qualities. The Duchess is surrounded by Chastity and Modesty; in front of her are Faith, holding a chalice with the Host, and Charity, carrying a pelican on her lap. In the triumphal scenes, the landscape that in the front panels had been rendered with Flemish sensitivity becomes a subject in its own right. The delicately sloping hills create a sense of quiet suited to the slow rhythm of the narrative.

BACKGROUND

The Marches after Piero

In order to fully appreciate Piero's artistic influence in the Marches, one must take into consideration the works he created for the court of Urbino, as well as others left in the region, which are now unfortunately lost. Around 1450, Piero worked in Loreto with Domenico Veneziano and, in later years, he was also active in Ancona and Pesaro. His rigorous but complex language was inspirational to any new artist operating in central Italy in the 1470s. Piero, however, never had any real pupils – many local painters preferred to move to Florence or Rome. Piero's meeting with Giovanni Santi, Raphael's father, was an event of historical importance: Giovanni felt much admiration and respect for the artist from Sansepolcro, as revealed in his *Rhymed Chronicles*, and his more gifted son was equally impressed. Piero's influence, however, is perhaps most

■ Giovanni Santi, *The Buffi Altarpiece*, 1489, Galleria Nazionale delle Marche, Urbino. In this *sacra conversazione*, Santi created a solid perspective structure around the throne of the Virgin.

noticeable in the pictorial decoration of the Basilica of the Santa Casa in Loreto, realized in about 1480 by Melozzo da Forlì, who had almost certainly come into contact with Piero while at the court of Urbino; and in the work of Luca Signorelli from Cortona.

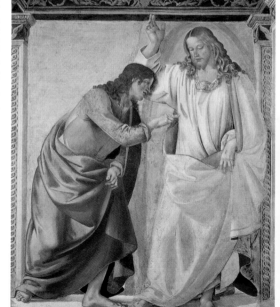

■ Luca Signorelli, *Doubting Thomas*, 1480, Sacrestia di San Giovanni, Basilica della Santa Casa, Loreto. The figures of the apostles are inserted within the architectural cornice. The monumental emphasis hints at the artist's interest in sculpture.

■ Luca Signorelli, *Flagellation*, c.1475–80, Pinacoteca di Brera, Milan. Around 1470, Signorelli might have been an apprentice in Piero's studio. Later he moved to Florence, where he studied Antonio Pollaiolo's new expressive research. Such various stimuli are all evident in this painting, originally executed for the church of Santa Maria del Mercato in Fabriano, in the Marches. Some elements of this work are explicit references to Piero's *Flagellation*, notably the pagan idol on the column to which Christ is tied, the scourgers and the figure of Christ himself. Instead of Piero's calm synthesis, however, Signorelli's style is one of vibrant dynamism, made more dramatic by the exaggerated movements of the semi-naked figures. It is through these tense nudes that Signorelli defines the narrative emotion of the event.

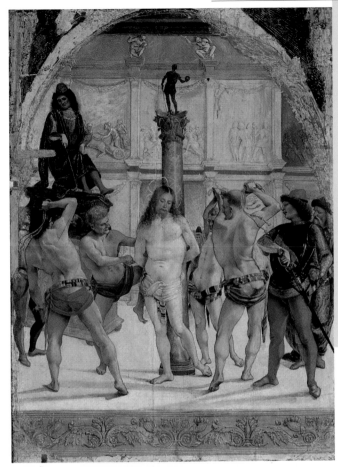

■ Melozzo da Forlì, *Vault of the Sacristy of San Marco*, detail, c.1480, Basilica della Sacra Casa, Loreto. In this painting Melozzo uses perspective in the rather scenic way that was typical of the Padua School. This portrayal of the pensive prophet Isaiah reveals Piero's influence in the bright light effects shaping the contours of the figure. A subtle sentimental tone contrasts with the skillful composition of the work.

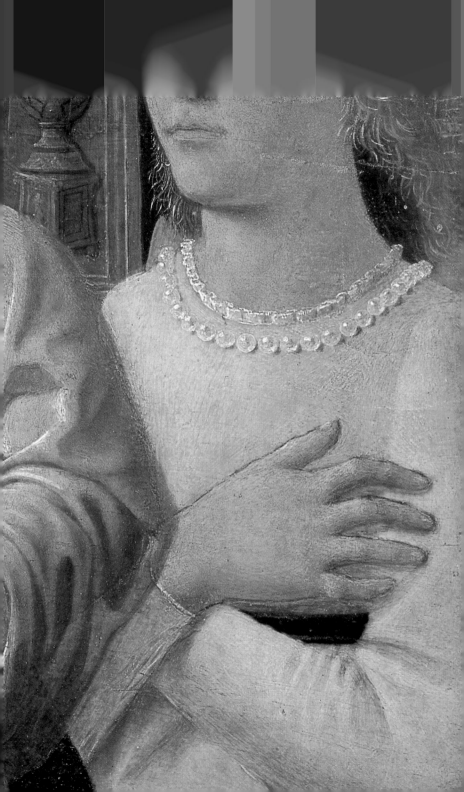

A luminous style

The increasing popularity of Flemish art in Italy reached a climax in about 1470: among the artists most influenced by the developments in northern Europe were Piero himself, Antonello da Messina, and Giovanni Bellini. Their approach to the light effects of Flemish painting allowed them to lay the foundation for possibly the best artistic chapter of the Italian Renaissance. Antonello da Messina studied in Naples, a city that at the time had many contacts with Flanders: here he developed his characteristic sensitivity for luminosity. He later travelled throughout Italy, and came into contact with Piero's studies of form and perspective. This was a fundamental step for Antonello's own research into the synthesis of light, space, and figures. It is from these various experiences that Antonello's peculiar style was born, a style that he elaborated even further after meeting Giovanni Bellini in Venice. The Venetian painter's artistic itinerary was not too different from Antonello's: after outgrowing the monumental, harsh style of his brother-in-law Andrea Mantegna, Bellini's direction focused on a more realistic rendition of light effects. He was an admirer of the luminous qualities depicted in Flemish art and, by incorporating it within his own works, Giovanni Bellini thus became the first true reformer of Venetian art at that time.

■ Top: Hans Memling, *Portrait of Tommaso Portinari*, 1470, The Metropolitan Museum of Art, New York.

■ Above: Antonello da Messina, *Portrait of a Man*, 1473, National Gallery, London. The three-quarter pose is typical of Flemish art. Antonello took great care to render the personality of the sitter: he emerges from a dark background with penetrating eyes.

■ Giovanni Bellini, *The Coronation of the Virgin*, central panel of the *Pesaro Altarpiece*, c.1471–74, Museo Civico, Pesaro. The balance of architecture and nature is achieved thanks to atmospheric light: it envelops the scene creating a grandiose, solemn composition.

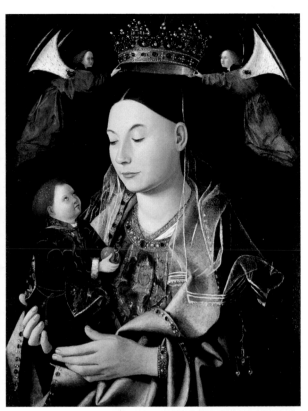

■ Antonello da Messina, *Madonna and Child*, c.1460, National Gallery, London. This painting contains the first successful synthesis of all the elements that Antonello had gathered. His analytical realism is found in the light bathing the Virgin Mary. The light emphasizes the beauty and richness of her embroidered cloak, and shines on her jewels and through her thin veil with a delicate effect also found in Mary's eyes. The face of the Virgin has an abstract quality about it: Antonello painted her like a Spanish Madonna, while following Piero's advice on geometry.

■ Giovanni Bellini, *Pietà*, c.1465, Pinacoteca di Brera, Milan. Bellini's first fully developed work gives a dramatic interpretation of a traditional subject. The characters in the painting are separated from the viewers only by a small parapet and have a simple, solemn dignity. The centrepiece of the painting is the silent dialogue between mother and son, made even more heartbreaking by the soft light that underlines the contrast between the living and the dead, between Christ's pale body and Mary's red cloak.

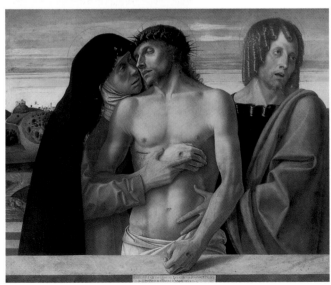

The Senigallia Madonna

This small painting (1475–78) was probably commissioned by Federico da Montefeltro to mark his daughter Giovanna's wedding to Giovanni della Rovere, lord of Senigallia. It is kept at the Galleria Nazionale delle Marche in Urbino.

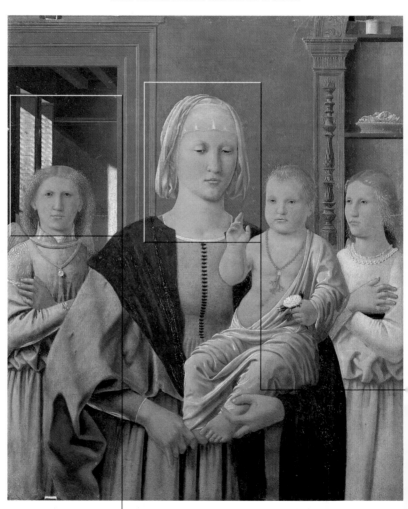

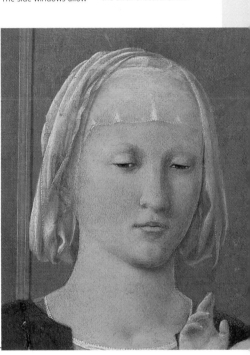

■ Jan van Eyck, *The Virgin in a Church*, c.1435, Gemäldegalerie, Staatliche Museen, Berlin. This small panel was an important model for Piero. The Virgin Mary is portrayed in a large Gothic church, the vaults of which seem to go on forever. The side windows allow an intense light to enter the church: it bathes the surfaces, bringing them to life, and is then reflected on the concrete. According to tradition, the light pouring in through closed windows is a hint to the mystery of the Immaculate Conception, which led to the birth of Jesus Christ.

■ The thin veil framing the face of the Virgin Mary creates subtle folds that reflect the light and emphasize her features. Piero, ever subtly sober in his approach, felt that haloes were not needed to suggest the divine superiority of the characters in the work.

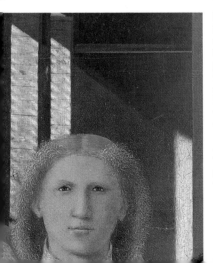

■ The scene takes place in a humble domestic environment. The room that contains the sacred group is not directly lit but, in the room next door, a ray of sunshine bursts through the open windows dispelling the darkness. The light is rendered in such a delicately detailed way that one can almost see tiny dust particles floating around. Piero's sensitivity to realism can also be observed in the basket in the niche, and the hair of the angel on the left-hand side, which is highlighted by golden reflections. This stern-looking angel looks out to the viewers, inviting them to be part of the subtle magic of this work. The success of this painting derives from Piero's perfect combination of form and light.

LIFE AND WORKS

The poetics of light

One of the elements that links Piero's works throughout his career is his careful rendition of light effects. He started his research into the use of light during his apprenticeship in Florence with Domenico Veneziano. Since oil painting allows for a smoother application of colors, Piero experimented with this technique, becoming increasingly proficient and eventually achieving extraordinarily truthful effects in the portrayal of reality. This research was almost certainly inspired by the Flemish style that had become ever more popular in Italian courts. Piero, however, developed his individual method, as revealed by recent restoration works: in *The Polyptych of St Antony*, for example, he also used his fingers and the brush handle to apply the color and suggest chiaroscuro effects. The rigorous setting of his first paintings is in later works replaced by a lyrical vision of reality rendered with a refined sense of color. Piero's research into the use of light in representing objects anticipates that of the Dutch painter Vermeer a century later.

■ Johannes Vermeer, *The Milkmaid*, detail, c.1658, Rijksmuseum, Amsterdam. In this painting, a domestic interior is decorated with everyday objects. Thanks to the clear light, even the most humble things like bread or the carafe are given a universal quality.

■ Piero della Francesca, *The Senigallia Madonna*, detail, c.1475–78, Galleria Nazionale delle Marche, Urbino. The wicker basket containing clean clothes is located in the semi-shade, where the light from the windows barely reaches it. The soft brushstrokes on the canvas contribute to a naturalistic effect that transforms the object into a splendid still life. In later years, Piero used light as an important narrative and symbolic element, as well as a means to soften the harshness of the forms.

■ Piero della Francesca, *The Brera Altarpiece*, detail, 1472–74, Pinacoteca di Brera, Milan. Piero investigated the possibilities of a detailed rendition of reality during his time in Urbino. One of the first results of his original research was this trompe l'œil. The shining metallic surface of the armor is perfectly polished to reflect the interior of the church. One of the nicest details on the armor is the reflection of the window shedding light on the proceedings in the painting. Such intense realism of this detail was unheard of at the time, and Piero's contemporaries must have felt the scene was almost real.

■ Jan van Eyck, *The Madonna with Canon van der Paele*, detail, 1436, Groningen Museum, Bruges. Piero's minute analysis of reality is similar to van Eyck's own research.

However, while the Flemish artist's attention to realism is indicative of his belief in an infinite world, Piero combined his studies in luminosity with his rational poetics, based on a clear, finite universe.

■ Piero della Francesca, *Diptych of the Uffizi*, reverse portraying *The Triumph of Federico da Montefeltro*, detail, c.1474, Galleria degli Uffizi, Florence. The clear lake set among the sloping hills is crossed by tiny boats reflected in the waters. Everything seems still wrapped in the early morning fog slowly rising above the valley. Piero expands the space of the painting by using a subtle light effect: the distance of the hills on the horizon is suggested by the decreasing intensity of the colors used. This atmospheric effect was to influence Leonardo.

Michael Pacher

Michael Pacher's artistic development was the result of a combination of Italian and German influences. The artist was born in Brunico, Italy, in about 1435. According to a well-established northern tradition, he became sculptor and painter, and had the opportunity to express his talents in impressive double-leafed altars that included a central sculpted casket and painted sides. Pacher's wooden works are decorated with complex golden details, and, as such, they respond to the criteria of the florid German late Gothic tradition; his paintings, on the other hand, show a distinct slant towards Italian art. His first important contact with the artistic language of the early Renaissance took place in Padua, in about 1465. In this city, the artist found an environment heavily influenced by the works of Donatello and Mantegna, and was inspired to begin his research on perspective that accompanied him throughout his career. The positive results of his experience in Padua also encouraged Pacher to travel further through Italy: he lived for some time in Florence, and then moved to Urbino, where he came into contact with Piero's work. Pacher's talent lies in being able to combine the narrative liveliness and bright luminosity typical of northern art with Italian perspective: this cultural "bilingualism" made him the first artist to act as a point of contact between northern and Mediterranean Europe, a role that was later assumed by Dürer.

■ Michael Pacher, *Attempted Stoning of Christ*, detail, 1479–81, Church of Sankt Wolfgang, Sankt Wolfgang, Austria. Piero's influence is visible in the faces of the men.

■ Michael Pacher, *The Bull of St Luke*, c.1477–78, Landesmuseum Joanneum, Graz. In this tiny panel the monumental bull, symbol of St Luke the Evangelist, is placed diagonally within the pictorial space. The effect of perspective is underlined by the book that seems to project out of the frame, while the powerful build of the animal is emphasized by intense light creating a strong chiaroscuro effect.

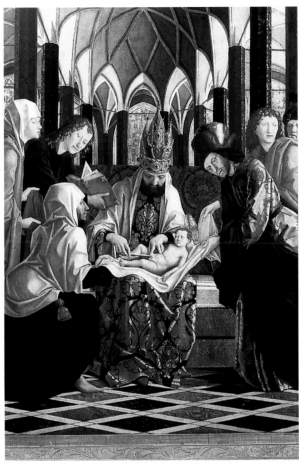

■ Michael Pacher, *The Circumcision of Christ*, 1479–81, Church of Sankt Wolfgang, Austria. This episode is one of the most accomplished among the ones that decorate the monumental double-leafed altar of the Church of Sankt Wolfgang, in the eponymous Austrian village. In the centre of the scene is the priest, looking down at the naked baby on his lap just as he is about to perform the circumcision. The priest wears a rich damask cloth and a mitre decorated with precious stones, and represents the symbolic as well as the spatial climax of this solemn composition. The structure within which the scene takes place is symmetrical and balanced, a fact that is underlined by the circular Gothic choir in the background, and the in the positioning of the figures around the central group. This painting is Pacher's northern reading of Piero's *Brera Altarpiece*.

■ Right: Michael Pacher, *The Presentation in the Temple*, 1479–81, Church of Sankt Wolfgang, Sankt Wolfgang, Austria.

■ Far right: Michael Pacher, *The Marriage of Cana*, detail, 1479–81, Church of Sankt Wolfgang, Austria. The rendition of these metal jugs, painted in a foreshortened position, proved that Pacher was confident with the creation of perfectly geometric objects.

117

The principles
of harmony

The tendency to apply mathematical laws in the creation of works of art did not develop in the Renaissance. In the Middle Ages, many paintings were executed in a similar manner, creating the structure of the composition by inserting simple geometrical shapes like circles, squares, and triangles. The mathematical ambitions of many artists were answered by the Golden Section, the rules of proportion meant to bring each individual component of the work within a homogenous whole. The search for a harmonic principle was a reflection of the desire to find a bridge between the real and the divine, and was still purely experimental. It was only in the 15th century that mathematical principles found a solid base thanks to the theoretical work of artists such as Alberti and Piero himself: even before the execution of a work, they tried to establish a scientific rule regulating the inner structure of the painting. Piero had a passion for geometry from a very young age, and he indulged it in his treatise on regular forms, *De quinque corporibus regolaris*, in which he gave a careful explanation on how to build geometrical volumes.

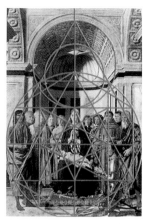

■ The graphic scheme built around the complex structure of the *Brera Altarpiece* leaves no doubts: the geometric construction makes it look similar to a crystal.

■ Piero della Francesca, *St Mary Magdalen*, detail, c.1468, Duomo, Arezzo. In this fresco the saint is portrayed holding a crystal cruet with a pointed lid. The perfectly cylindrical shape of the vase is emphasized by the perspective position and by the subtle nuances of color that create the effect of roundness. A beautiful chromatic effect is created by the contrast between the shades of white and grey of the cruet and Mary Magdalen's bright red and green clothes.

■ Piero della Francesca, *The Meeting of Solomon and Sheba*, detail, c.1459–64, San Francesco, Arezzo. This nobleman, seen from behind, is wearing an extravagant hat called a *mazzocchio*. Piero was faced with the problem of how to render a perfectly spherical object in a coherent, realistic way. As ever, Piero excelled himself: the light shining on the soft folds of the material alters its color. In all likelihood, Piero was probably inspired by Paolo Uccello, who had often experimented with this very type of object.

■ Piero della Francesca, *Madonna and Child with Four Angels (The Williamstown Altarpiece)*, detail, c.1478–80, Sterling and Francine Clark Art Institute, Williamstown.

In this painting Mary's head is placed in relation to the capital holding up the architrave. This stylistic solution derives from Piero's research into Vitruvius' study of proportions.

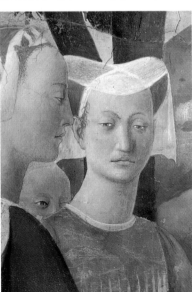

■ Piero della Francesca, *The Adoration of the Sacred Wood*, detail, c.1459–64, San Francesco, Arezzo. The face of this young maid is the perfect oval often used by Piero in the portrayal of his female figures. This is an example of pure formal abstraction, made even more unsettling by the semi-closed eyelids of the woman. Piero was known for using the same pattern for more than one figure, as if to underline the universality of mankind. In this way his figures, forms of geometrical purity, become symbols of a superior, super-natural truth.

The writer of treatises

■ Below left: *Perspective of a Building*, in Piero's *De Prospectiva Pingendi*, c.1475–80, cod. S.P. 6 bis, fol. 25 v., Biblioteca Ambrosiana, Milan. Although Alberti had already written a treatise with a section on perspective, Piero's theoretical work is the first Renaissance text totally devoted to the realistic rendition of objects in space.

■ Below: *Composite Capital*, in Piero's *De Prospectiva Pingendi*, c.1475–80, cod. 1576, fol. 54 v., Biblioteca Palatina, Parma. The rigorous text of the treatise is accompanied by drawings explaining solutions to the problems discussed. This page shows a plan and different perspectives of a capital.

Piero was a mathematical theorist as well as a painter. Indeed, his treatises were so influential that, in his *Lives of the Most Excellent Painters, Sculptors, and Architects*, Vasari wrote that some of Piero's writings on geometry and perspective put him on a par with any mathematician of his time. The artist's passion for mathematics started with his schooling: as the son of a merchant, most of his academic formation consisted of subjects useful for the family profession. Piero dedicated his first text, *Trattato de Abaco*, to a merchant from Sansepolcro. Written in the 1460s, the treatise is a manual on arithmetic; it also contains ideas on algebra and a section on geometric solids that was to form the basis of one of Piero's later treatises in Latin. The artist's second and most theoretical effort is *De Prospectiva Pingendi*, written during his time in Urbino, and dedicated to Federico da Montefeltro, who had a lively interest in architecture. In this text, Piero tried to define a universe regulated by the laws of perspective. His *De Quinque Corporibus Regolaribus* is a treatise on regular solid forms. It was completed in about 1485 and dedicated to Guidubaldo of Urbino, a fact that highlights Piero's excellent rapport with the Montefeltro court.

■ Gregor Reisch, *Arithmetic with an Abacus and the Arab Numerical System*, from *Margarita Philosophica*, 1508, Basel.

■ This copy of a painting by Santi di Tito (Museo Civico, Sansepolcro) portrays Piero as a humanist. On the table is a text by Euclid, the presence of which confirms that Piero's fame had been achieved thanks to his ability to apply mathematical rules to his art.

■ *Head*, in Piero's *De Prospectiva Pingendi*, c.1475–80, cod. S.P. 6 bis, fol. 82 v., Biblioteca Ambrosiana, Milan. Piero's text is not the work of a literary man, but rather a sober and rigorous sequence of mathematical demonstrations meant to capture and explain the laws governing perspective. The treatise is a kind of practical manual progressing from the simple representation of planes and surfaces to the more difficult rendition of solids in space. Piero also describes the best way to portray complex figures, such as the human body, by providing drawings from different points of view, as illustrated by this projection of a head.

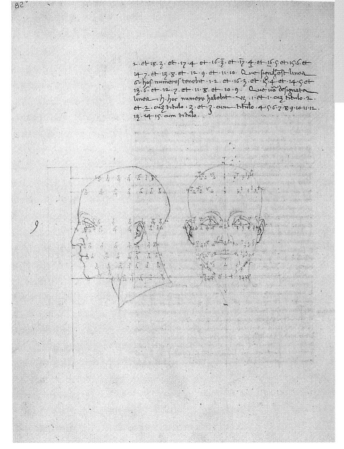

BACKGROUND

Piero's friendship with Luca Pacioli

Luca Pacioli was a Dominican friar born in Sansepolcro with whom Piero established a strong, close friendship. Born in about 1445, Pacioli devoted his whole life to the study of mathematics, a subject he also taught in many universities, including Bologna, Rome, and Venice. A much admired and respected character, he found an ideal ground for his talents at the court of Urbino, where his friendship with Piero blossomed. The artist and the friar were both attempting to find solutions to complex mathematical questions, not least the problem of how to construct simple, regular forms. The results of his research were collected in a series of texts, including his *Summa de Arithmetica* from 1494 and the indispensable *De Divina Proportione*, completed in 1498, but only published in 1509 in Venice. Even the title of this work suggests its ambitious plan: as the first rational writing on the Golden Section, it includes the different mathematical applications of proportions. Pacioli, however, was not an innovator, but rather a skillful popularizer: thanks to his works, the rules on proportions that had been jealously guarded in painters' studios became available to all artists.

■ Pacioli taught at the University of Bologna between 1501 and 1502. These reliefs, executed in memory of the most illustrious teachers, show a tutor at his desk surrounded by his pupils. They are kept at the Civico Museo Medievale in Bologna.

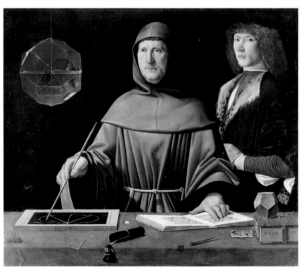

■ Jacopo de' Barbari, *Portrait of friar Luca Pacioli and Duke Guidubaldo da Montefeltro*, 1495, Gallerie Nazionali di Capodimonte, Naples. This painting is a moral work by Pacioli. The Dominican friar tracing a geometrical shape on a board is surrounded by the tools of his trade, and helped by one of his pupils, Guidubaldo da Montefeltro. The work was completed in Urbino, as proven by the reflection of the Ducal Palace in the glass polyhedron hanging by the two men.

■ *De Divina Proportione*, illuminated title page from one of the four handwritten copies. The last section of Pacioli's text is so similar to Piero's treatise on regular bodies that the Dominican friar was accused of plagiarism. He completed this work while he was at the court of Milan and dedicated it to Ludovico il Moro. Leonardo da Vinci, who, like Piero and Pacioli, had a passion for sciences, illustrated one of the copies of this text.

■ *Solid with 72 Faces*, from an original by Leonardo, in *De Divina Proportione*, Biblioteca Ambrosiana, Milan. Leonardo's work gives no indication of his study on the geometrical shapes of regular bodies.

His restlessness and versatile talent led Leonardo to both art and sciences. His main passion, however, was not geometry, but rather hydraulics and astronomy, two fields that satisfied his thirst for new knowledge.

■ Piero della Francesca, *The Brera Altarpiece*, detail, 1472–74, Pinacoteca di Brera, Milan. In the features of St Peter behind Federico da Montefeltro, one can recognize Luca Pacioli. This portrait is an explicit homage to the mathematician. It is not a coincidence that a portrait of the scholar of Euclidian theorems was inserted in Piero's most complex work, the painting featuring the most subtle geometrical and proportional elements, and the most important one created for the Duke of Montefeltro. Conversely, in his *Summa de Arithmetica*, Pacioli openly praised the artist, giving a detailed list of his works. The friar, who came into contact with all the main artists of the time from Botticelli to Dürer, became the official spokesperson for Piero's ideas. He managed to spread interest for the mathematical and perspective rendition of reality, a fact that was vastly influential to the next generation of artists.

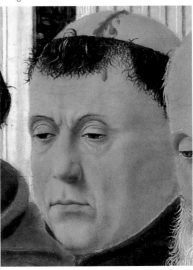

The Nativity

This painting, the ultimate result of Piero's pictorial research, was executed in about 1482, and left unfinished. Its surface has been ruined by an attempt to clean it. The painting is kept at the National Gallery in London.

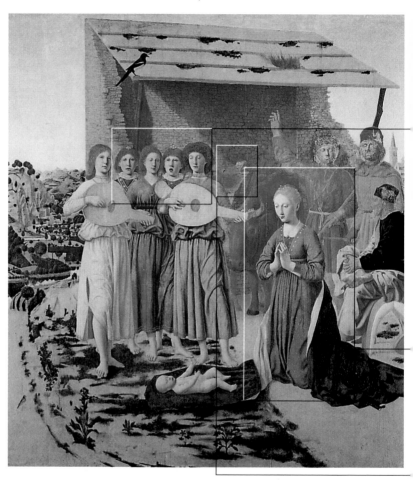

■ Right: Luca della Robbia, *Choir*, detail, 1431–38, Museo dell'Opera del Duomo, Florence. Piero's singing angels in the painting are a homage to della Robbia, the Tuscan sculptor who died in 1482. The classical postures of Luca's cherubs express an ideal of beauty that is perfectly in tune with the serious tone of Piero's own work. The scene depicted takes place in a simple rural environment.

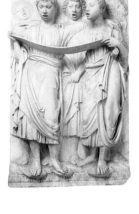

■ The singing angels seem pensive, their faces barely expressing a feeling of joy. The incomplete nature of the work is revealed in the lack of strings on the musical instruments.

■ The muzzle of the donkey is an amazingly realistic detail. The animal seems to join the celestial choir of the angels, but it also represents a discordant note: a braying donkey, in fact, is an allusion to the Apocalypse.

■ The Virgin Mary has shed the iconic fixed gaze typical of Piero's female characters. The features of her face are softened by the shadows, and her quiet demeanor is emphasized by the subtle colors of her clothes.

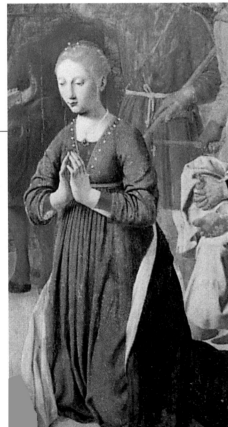

The art of perspective

The research into the mathematical laws that enable the realistic rendition of a three-dimensional object on canvas engaged many artists of the early Renaissance. The Italian achievements in the field of perspective and harmonious proportions attracted many foreign artists to the country, especially those who, like Dürer, were interested in a rational account of the rules regulating pictorial works. Although Piero della Francesca played an important role within this cultural climate, his itinerary is far more complex than suggested at first glance by his reputation as painter and scientist. Piero's treatise on perspective is the ultimate result of his research in this field: it is a work that relies heavily on theoretical mathematical laws, and that, by its very nature, is disconnected from the difficulties of a pictorial exercise. In his own works, Piero found himself dealing with the gap between abstract rules and the expressive needs of the composition. His perspective talents developed gradually over a period of several years and, indeed, his expressive freedom sometimes clashes openly with the rigidity of the theories behind the pictorial creation. If, in *The Flagellation*, Piero seemed to have achieved absolute mathematical perfection, with his *Nativity* he consciously gave up the rigors of symmetrical composition typical of his earlier works.

■ Piero della Francesca, *The Annunciation*, detail from the *Polyptych of St Antony*, c.1467–68, Galleria Nazionale dell'Umbria, Perugia. The colonnade opening up within the arches proves Piero's perspective talents. His passion for perspective and architecture allowed Piero to establish a rich dialogue with the theorists and architects he met throughout his career, notably Alberti, Laurana, and Francesco di Giorgio.

■ Piero della Francesca, *The Proving of the Cross*, detail, c.1459–64, San Francesco, Arezzo. In the Arezzo frescoes, architecture divides the narrative sequence into episodes. Among these buildings, Piero also painted a circular-shaped temple. According to the ideals of the time, this type of building embodied proportional harmony.

■ Piero della Francesca, *The Flagellation*, detail, c.1460–65, Galleria Nazionale delle Marche, Urbino. The real protagonist in Pilate's palace is space, its sense of harmony defined by the characters.

■ Piero della Francesca, *The Discovery of the Sacred Wood*, detail, c.1459–64, San Francesco, Arezzo. This white horse is a monumental figure. The geometrical rendition of its body and mane underline its strength.

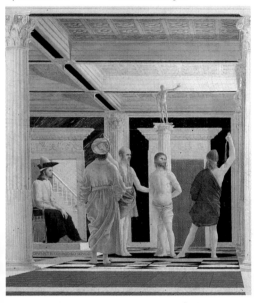

■ Piero della Francesca, *St Jerome and a Worshipper*, detail, c.1460, Gallerie dell'Accademia, Venice. Many artists placed an open book, originally a Flemish motif, in their works to show their ability with perspective. Piero paints St Jerome as he moves an open book towards the viewer in a gesture that underlines the light effects on the page.

Piero's heritage

Although Piero did not have any immediate heirs, his activity in central Italy had a decisive importance all over the country. His theoretical research on volumes and solids was popularized by Luca Pacioli in *De Divina Proportione*, and his paintings played an influential role for many artists. The expressive solemnity, careful attention to perspective and geometrical details, and logical rigor that Piero used in his art came to constitute the base for an important artistic direction in the 16th century. The most ingenious exponent of this trend was Donato Bramante, whose formation took place at the court of Urbino while the city was still the capital of mathematical and perspective studies. After some time in Mantua, Bramante moved to the Milanese court of Ludovico il Moro where, around the same time, Leonardo da Vinci was also expressing his eclectic talents. It was in Milan that the painter achieved his first results in a monumental style that put him firmly on the map of the contemporary artistic panorama. A lesser known, but equally original follower of Piero's style was Bartolomeo della Gatta, a Florentine illuminator and painter who, after studying with Andrea Verrocchio, moved to Arezzo, where he was impressed by Piero's frescoes.

■ Bartolomeo della Gatta, *Assumpta Hands Her Belt to St Thomas*, c.1470–75, Museo Diocesano, Cortona. This grandiose altarpiece combines Bartolomeo's ability to dominate space with his narrative talent expressed in the brightly lit details – from the surprised faces of the apostles to the richly decorated clothes of the celestial choir.

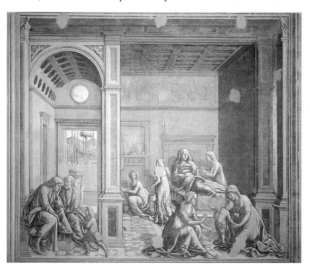

■ Francesco di Giorgio Martini, *Birth of the Virgin* c.1490–74, Sant'Agostino, Cappella Bichi, Siena. Due to his activity as an architect and a military engineer, Francesco, a versatile artist in the vein of Leonardo, did not devote himself to painting with continuity. However, he must have kept abreast with contemporary developments, as proven by this monochrome scene, in which he reinterpreted the great tradition from Siena through Piero's spatial and architectural lucidity.

■ Bartolomeo della Gatta, *St Lawrence*, 1467, Duomo, Arezzo. The saint is portrayed holding a grille, symbolic of his martyrdom. He has a sculpted feel as he leans out of the marble recess.

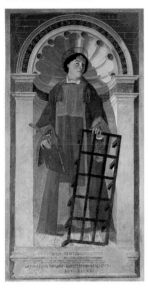

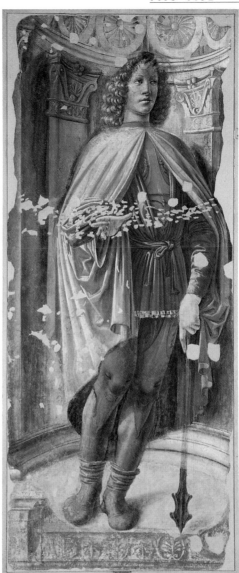

■ Donato Bramante, *Youth Holding a Mace*, 1486–87, Pinacoteca di Brera, Milan. This painting reveals Bramante's inclination towards theatrical poses.

■ Donato Bramante, Choir of Santa Maria presso San Satiro, 1482–86, Milan. In this church Bramante indulged his passion for both architecture and painting. Space restrictions forced him to create a false choir in stucco, which is only 90 cm (35.4 in) deep. The illusion of space is helped by the rich decoration of the coffered vault, inspired by Piero's *Brera Altarpiece*.

The discovery of a new world

In his final years, Piero gradually detached himself from public life and concentrated on writing his treatise on regular forms, which he completed in 1485. In his dedication to Guidubaldo da Montefeltro, the artist declared his desire to avoid the decline of his intellectual faculties through a detailed mathematical study. The waning of his artistic career was partly due to a sight problem that almost resulted in blindness. In 1487, however, he personally drew up his own will. After the death of Federico da Montefeltro, Piero's artistic isolation increased and he returned to work in his hometown. He was excluded from the main commission of the time – the decoration of the walls of the Sistine Chapel under by Pope Sixtus IV. It is ironic, however, that most of the young artists called by the Pope to execute the frescoes, including Signorelli, Perugino, and Bartolomeo della Gatta, had been greatly inspired by Piero's achievements. Piero died on October 12, 1492: the day Christopher Columbus discovered America.

■ This is one of the first geographical maps to include the lands in the new world. It depicts a part of South America.

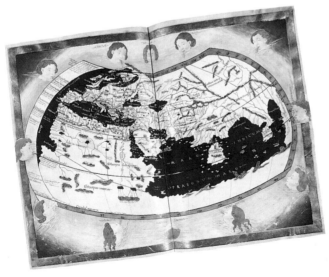

■ Ptolemy, *Geography*, manuscript from the second half of the fifteenth century, Biblioteca Medicea Laurenziana, Florence. The discovery of America opened a new geographical horizon, but also a psychological one within humankind. Piero's death coincided with the decline of old certainties: this can be seen as symbolic of the artist's ideal and historical position at the end of the Middle Ages. The medieval era was a time during which people accepted the limitations of a closed, perfectly confined world and tried to capture its secrets by studying the laws governing it.

■ Sebastiano del Piombo, *Portrait of Christopher Columbus*, 1519, The Metropolitan Museum of Art, New York.

■ Piero della Francesca, *The Resurrection*, detail, c.1467–68, Museo Civico, Sansepolcro.

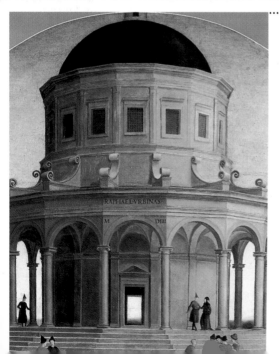

Raphael Urbinas

More than any other artist, Raphael rediscovered and reinterpreted Piero's calm vision, making it the central point of the "modern manner". The son of Giovanni Santi, Raphael was born in Urbino, and patronized by Giovanna Feltria, daughter of Federico da Montefeltro, for whom Piero painted *The Senigallia Madonna*. The classical, structure in this detail from *Marriage of the Virgin*, (1504, Pinacoteca di Brera, Milan) is enveloped in a warm light that caresses its surfaces and accompanies the viewer beyond the door of the temple, in an impressive atmospheric and luminous expansion.

Piero's legacy

Several creative developments characterized the approaching twentieth century in France. After Impressionism's 20-year monopoly, younger generations continued to research into a new artistic language. Georges Seurat's talent and Paul Cézanne's study into forms prepared the ground for many avant-garde currents of the 1900s, while at the same time causing leading painters to re-evaluate artistic movements of the past. Seurat's short, but highly influential career is based mostly on the optical and scientific rendition of reality: his paintings embody his theories on pure colors and research into the balance of a composition. Cézanne's desire to provide an analytical representation of nature led him to an increasing simplification of the forms, a style that paved the way for Cubism. In the early 1900s, Italy witnessed the innovations introduced by Futurism in the name of progress. After World War I, however, a climate of order began to prevail: artists tried to reconcile the achievements of the avant-garde trends with a rediscovery of the national pictorial tradition. The need to establish a link between artistic expression and cultural background was the reason behind the subtle archaism typical of many twentieth-century Italian artists.

■ Massimo Campigli, *The Builders*, 1928, Private Collection, Switzerland. During the fascist regime, Italy witnessed a re-evaluation of the Renaissance fresco technique: it was meant to stimulate the birth of a national style.

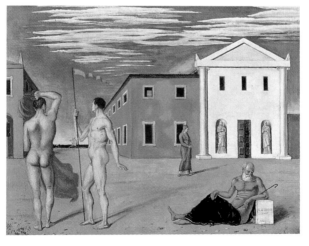

■ Giorgio de Chirico, *The Departure of the Argonauts*, 1920, Private Collection. De Chirico was the founder of Metaphysical painting. His fascination with the technical elements of Italian classicism is evident in his work, but his research into the Italian Renaissance was more than a mere nostalgic interpretation of the past: it has a polemical flavor and was intended as a critique of avant-garde European trends.

■ Georges Seurat, *A Sunday on La Grande Jatte*, 1884–86, The Art Institute of Chicago. Pointillism is the application of pure color in small dots that the eye of the viewer instinctively combines into a harmonious whole. The Pointillists portrayed reality in a comprehensive way, yet their scenes were steeped in an absolute stillness that recalls the works of Piero.

■ Felice Casorati, *Silvana Cenni*, 1922, Private Collection, Turin. This work is a direct homage to Piero's female figures and exact style. The geometrical perfection of the composition does not disguise a subtle feeling of apprehension suggested by the silver light enveloping the scene.

■ Paul Cézanne, *View of Gardanne*, 1885–86, The Museum of Modern Art, New York. Cézanne focuses on a few motifs repeated throughout the painting. The forms in this work reveal a neat system of geometrical solids, clearly reminiscent of Piero's works.

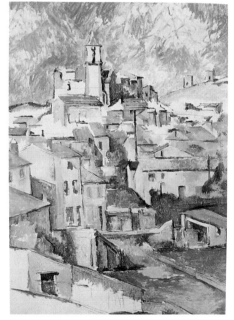

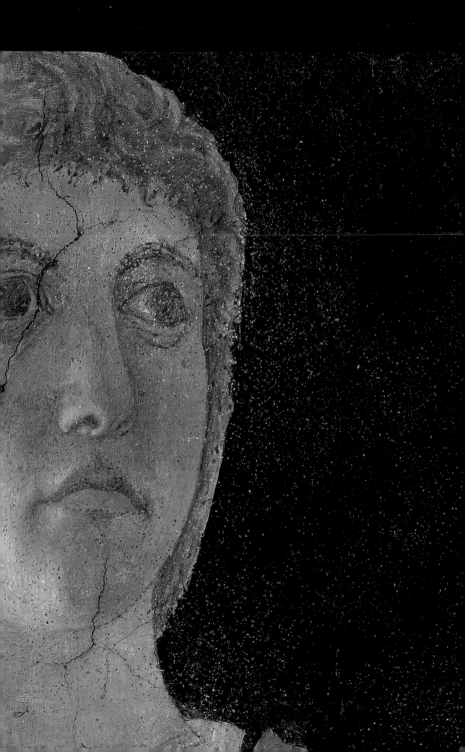

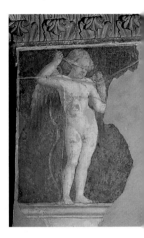

■ Piero della Francesca, *Cupid*, c.1459–64, San Francesco, Arezzo.

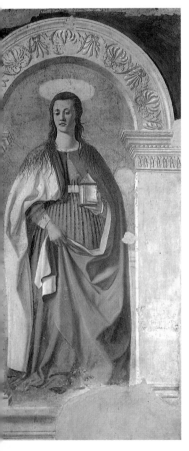

■ Piero della Francesca, *St Mary Magdalen*, c.1468, Duomo, Arezzo.

■ Piero della Francesca,
St Augustine, c.1465,
Museo de Arte
Antiga, Lisbon.

■ Piero della Francesca,
St Nicholas of Tolentino,
c.1465, Museo Poldi
Pezzoli, Milan.

■ Piero della Francesca,
St Michael, c.1465,
National Gallery, London.

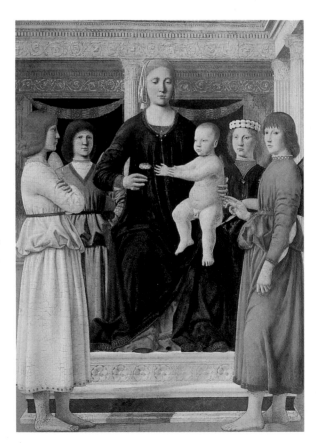

■ Piero della Francesca,
*Madonna and Child
with Four Angels (The
Williamstown Altarpiece)*,
c.1478–80, Sterling
and Francine Clark Art
Institute, Williamstown.

Note

All the names mentioned here are artists, intellectuals, politicians, and businessmen who had some connection with Piero, as well as painters, sculptors, and architects who were contemporaries or active in the same places as Piero, or who were influenced by him and his works.

■ Antonello da Messina, *St Sebastian*, c.1475–76, Gemäldegalerie, Dresden.

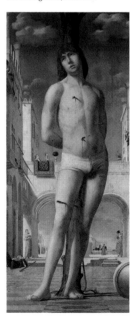

Agostino di Duccio (Florence 1418 – Perugia 1481), sculptor and architect. Driven out of Florence, he worked in Venice, Modena, and Rimini, where he decorated the Tempio Malatestiano. His artistic path led him to reduce forms to pure linear rhythms, pp. 26, 28–29, 80–81.

Alberti, Leon Battista (Genoa 1406 – Rome 1472), architect, art theorist, writer, and one of the key figures of the Renaissance. From detailed archeological studies, he was able to create architectural works, such as the Basilica di Sant'Andrea in Mantua and the Tempio Malatestiano in Rimini, that reflected his humanistic view of history. His treatises gave a solid theoretical and scientific base to the arts, giving them as much relevance as other humanistic disciplines, pp. 20, 26, 28–29, 32–33, 42, 46, 68, 79, 86, 102, 118, 120, 126.

Andrea del Castagno (Castagno, Mugello, c.1421 – Florence 1457), painter who studied in Florence during the city's humanistic phase, and worked almost exclusively in the Tuscan capital. Among his main works are the frescoes in the refectory of the Convento di Sant'Apollonia, portraying the life of Christ. A talented artist of perspective, he had an energetic, harshly realistic style, pp. 20, 38, 40–41, 69.

Antonello da Messina, real name Antonello di Antonio, (Messina c.1430–79), painter. His career began in Naples, but he travelled extensively to Rome, where he might have met Piero della Francesca and Fra Angelico, and Venice, where he met Giovanni Bellini. His journeys allowed him to enrich his artistic language: he created a complex stylistic combination of Flemish naturalism and the Italian passion for formal perfection, pp. 110–111.

Bartolomeo della Gatta, real name Pietro d'Antonio Dei, (Florence 1448 – Arezzo 1502), painter and illuminator. A Camaldolite monk, he was especially active in Arezzo and Rome. His style is a mixture of Verrocchio's naturalism and Piero's formal rigor, pp. 128–130.

Bellini, Gentile (c.1430–1507), painter, son of Jacopo and brother of Giovanni, also painters. Mostly known as a portrait artist, Bellini welcomed the young Titian as an apprentice in his studio, p. 37.

Bellini, Giovanni (Venice c.1432–1516), painter, son of Jacopo and brother of Gentile and the greatest of the three. In 1483 he became the official painter of the Republic of Venice, turning the city into a centre of artistic importance, pp. 27, 76, 110–111.

Benedetto da Maiano (Maiano, Florence 1442 – Florence 1497), architect and sculptor. His architectural works were inspired by Brunelleschi, while his sculptures were influenced by Bernardo Rossellino and Domenico Ghirlandaio, pp. 46, 94–95.

■ Donato Bramante,
Christ at the Column,
c.1490, Pinacoteca
di Brera, Milan.

Berruguete, Pedro (Paredes de Nava 1450/55 – Ávila c.1504), Spanish painter. He took part in the decoration of Federico da Montefeltro's studiolo, in which he combined Flemish and Italian elements, pp. 90, 94, 97.

Bessarione, cardinal who supported Pope Pius II's idea of a crusade against the Turks, pp. 43, 53.

Bicci di Lorenzo (Florence 1373 – Arezzo 1452), painter who was active in Tuscany in the late 14th century. He was responsible for the decoration of the choir of the Chiesa di San Francesco in Arezzo. This work was later completed by Piero della Francesca, pp. 46–47.

Boccati, real name Giovanni di Piermatteo, (Camerino, active between 1445 and 1480), Italian painter whose formation was rooted in the late Gothic tradition. Although influenced by Domenico Veneziano and Piero della Francesca, he remained faithful to his original style, pp. 72–73, 80.

Bonfigli, Benedetto (Perugia c.1420–96), Italian painter whose works are characterized by a lively and graceful style. He decorated the Palazzo dei Priori in Perugia, pp. 80–81.

Botticelli, real name Sandro Filipepi, (Florence 1445–1510), painter who combined a naturalistic inspiration with a tendency to formal abstraction. However, he failed to achieve this balance in his later works, which are characterized by an increasing

emphasis on shading and linear sketches. The reasons for this change can be sought in the rise of Savonarola and the crisis of Platonic ideals at the Florentine court, pp. 17, 84, 87, 123.

Bramante, real name Donato di Pascuccio di Antonio, (Monte Asdruvaldo, near Fermignano, Pesaro, 1444 – Rome 1514), Italian architect and painter. He studied in Urbino, at the Montefeltro court, and may have been active as a painter of perspective in Piero's circle. Pictorially, he was attracted to Mantegna's art while, as an architect he was the heir to Brunelleschi and Alberti. He applied perspective elements to create a sense of spatial illusion in his works. He worked in Milan for Ludovico il Moro, and in Rome, where he became one of the protagonists of the urban renewal of the city, pp. 86, 128–129.

Brunelleschi, Filippo (Florence 1377–1446), architect and sculptor. An ingenious innovator, he changed the definition of the architect's role from master builder to designer. His passion for classical architecture enabled him to develop revolutionary technical solutions such as those applied to the dome of Santa Maria del Fiore in Florence, pp. 12–13, 16, 32, 82.

Campigli, Massimo (Florence 1895 – Saint Tropez 1971), painter. Campigli had a passion for primitive, Egyptian, and Etruscan art, from which he drew inspiration for his own works. He created a timeless dimension by mixing reality and myth, p. 132.

Caporali, Bartolomeo (Perugia c.1420–1506/09), Italian painter and illuminator, who operated mostly around Perugia. Influenced by Benozzo Gozzoli, his later works are indebted to Pinturicchio, p. 80.

Casorati, Felice (Novara 1886 – Turin 1963), Italian painter who was heavily influenced by classical art. His later works are characterized by large static shapes enclosed within a cubic perspective space, p. 133.

Cézanne, Paul (Aix-en-Provence 1839–1906), French painter whose work is typified by a detailed study of synthesis and the essence of form and space, p. 132.

■ Paul Cézanne, *Still Life with a Black Clock,* c.1870, Private Collection.

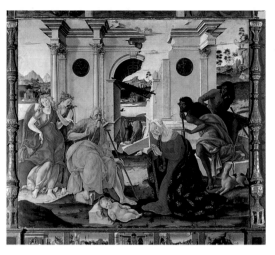

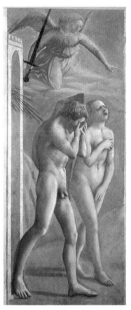

■ Francesco di Giorgio Martini, *Nativity*, 1485–90, San Domenico, Siena.

■ Masaccio, *The Expulsion of Adam and Eve*, 1424–25, Santa Maria del Carmine, Brancacci Chapel, Florence.

at first, and then Michelozzo Michelozzi and Leon Battista Alberti. His delicate style was appreciated by many artists and can be best observed in the Villa of Poggioreale, inspired by ancient Roman villas, p. 46.

Giulio Romano, real name Giulio Pippi, (Rome 1499 – Mantua 1546), painter and architect. Student and assistant of Raphael, he completed the decoration of the Vatican Rooms after the death of his mentor. In Mantua, at the Gonzaga court, he designed and frescoed the Palazzo del Tè, p. 49.

Gonzaga Ludovico II, Duke of Mantua, pp. 33, 86.

Guidantonio da Montefeltro, father of Federico, pp. 88, 99.

Guidubaldo da Montefeltro, son of Federico, pp. 96–97, 98, 101, 120, 122, 130.

Jacobus da Voragine, author of *The Golden Legend*, p. 48.

Joos van Ghent, (documented 1460–75), Flemish painter. From 1471 he worked at the Montefeltro court, where he

executed the *The Communion of the Apostles* and several portraits of illustrious men for Duke Federico's studiolo, pp. 90, 94, 97.

Landino, Cristoforo (Florence 1424 – Pratovecchio, Arezzo 1498), humanist who taught Lorenzo the Magnificent, Marsilio Ficino, and Poliziano. He also wrote several treatises, and supported the development of the Italian language, claiming the linguistic centrality of Florence, p. 89.

Laurana, Francesco (Zadar, c.1430 – Avignon? c.1502), Dalmatian sculptor and medallist. He executed marble portraits for Isabella of Aragon and Battista Sforza, pp. 90, 96.

Laurana, Luciano (Zadar, c.1420 – Pesaro 1479), Dalmatian architect. He was familiar with the innovations introduced by Alberti and, in 1466, worked in Urbino, on the Montefeltro palace. He absorbed the pre-existing structural elements of the building into a composite whole, pp. 90, 98, 126

Leonardo da Vinci (Vinci, Florence 1452 – Cloux Castle, Amboise 1519), painter, sculptor,

architect, engineer, and writer. A student of Verrocchio, he absorbed and reworked the elements of the Florentine Renaissance into his own individual style. He moved to Milan, then to Rome, where he only stayed for a few years, before finally settling in France. He believed that, in order to achieve a "universal" result, art could not be separated from the research into nature, pp. 67, 86, 115, 123, 128.

Lionello d'Este, Lord of Ferrara, pp. 24–25.

Lippi, Filippo (Florence 1406 – Spoleto 1469), painter. Influenced by Masaccio and Fra Angelico, he had a graceful style, pp. 18–19.

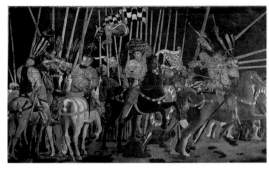

■ Paolo Uccello, *The Battle of San Romano*, c.1456, Musée du Louvre, Paris.

■ Perugino, *Madonna with Child and two Female Saints*, c.1480, Musée du Louvre, Paris.

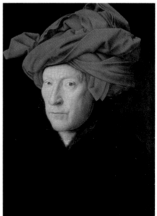

■ Jan van Eyck, *The Man with the Red Turban*, 1433, National Gallery, London.

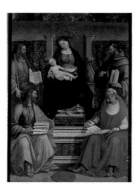

■ Luca Signorelli, *Madonna Enthroned with Child and Saints*, 1507, Pinacoteca di Brera, Milan.

A DK PUBLISHING BOOK
www.dk.com

TRANSLATOR
Sylvia Tombesi-Walton

DESIGN ASSISTANCE
Joanne Mitchell

EDITORS
Susannah Steel, Jo Marceau

MANAGING EDITOR
Anna Kruger

Series of monographs
edited by Stefano Peccatori and Stefano Zuffi

Text by Tatjana Pauli

PICTURE SOURCES

Archivio Electa, Milan
Elemond Editori Associati wishes to thank all those museums and
photographic libraries who have kindly supplied pictures, and would be pleased
to hear from copyright holders in the event of uncredited picture sources.

Project created in conjunction with
La Biblioteca editrice s.r.l., Milan

First published in the United States in 1999 by DK Publishing Inc.
95 Madison Avenue, New York, New York 10016

Piero della Francesca, 1416?–1492.
 [Piero della Francesca. English]
 Piero della Francesca. --1st American ed.
 p. cm. -- (ArtBook)
 Includes index.
 ISBN 0-7894-4853-X (alk. paper)
 1. Piero, della Francesca. 1416?–1492 Catalogs. I. Title. II. Series: Artbook
 (Dorling Kindersley Ltd)
 ND623.F78A4 1999
 759.5--dc21 99-31209
 CIP

First published in Great Britain in 1999
by Dorling Kindersley Limited,
9 Henrietta Street, London WC2E 8PS

A CIP catalogue record of this book is available from the British Library.

ISBN 0751307807

2 4 6 8 10 9 7 5 3 1

Printed by Elemond s.p.a. at Martellago (Venice)